Portraits Album

WELCOME AND THANK YOU! Each page is a portrait, suitable for cut-out and framing. This album is a nice conversation piece in your sala or coffee table. Published by Tatay Jobo Elizes, ISBN 13: 978- 1548092313 & ISBN 10: 1548092312

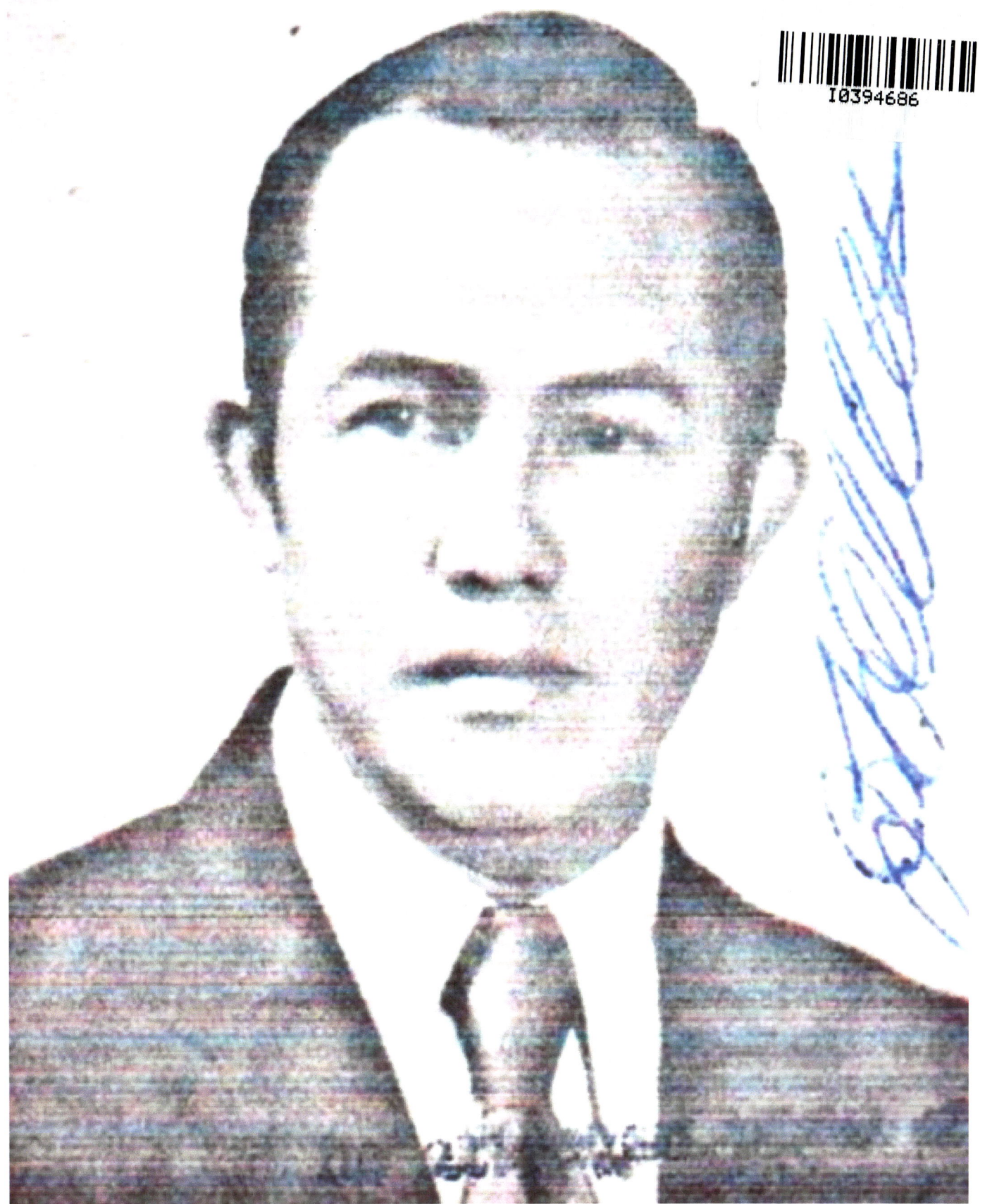

Tatay Jobo, 1960s

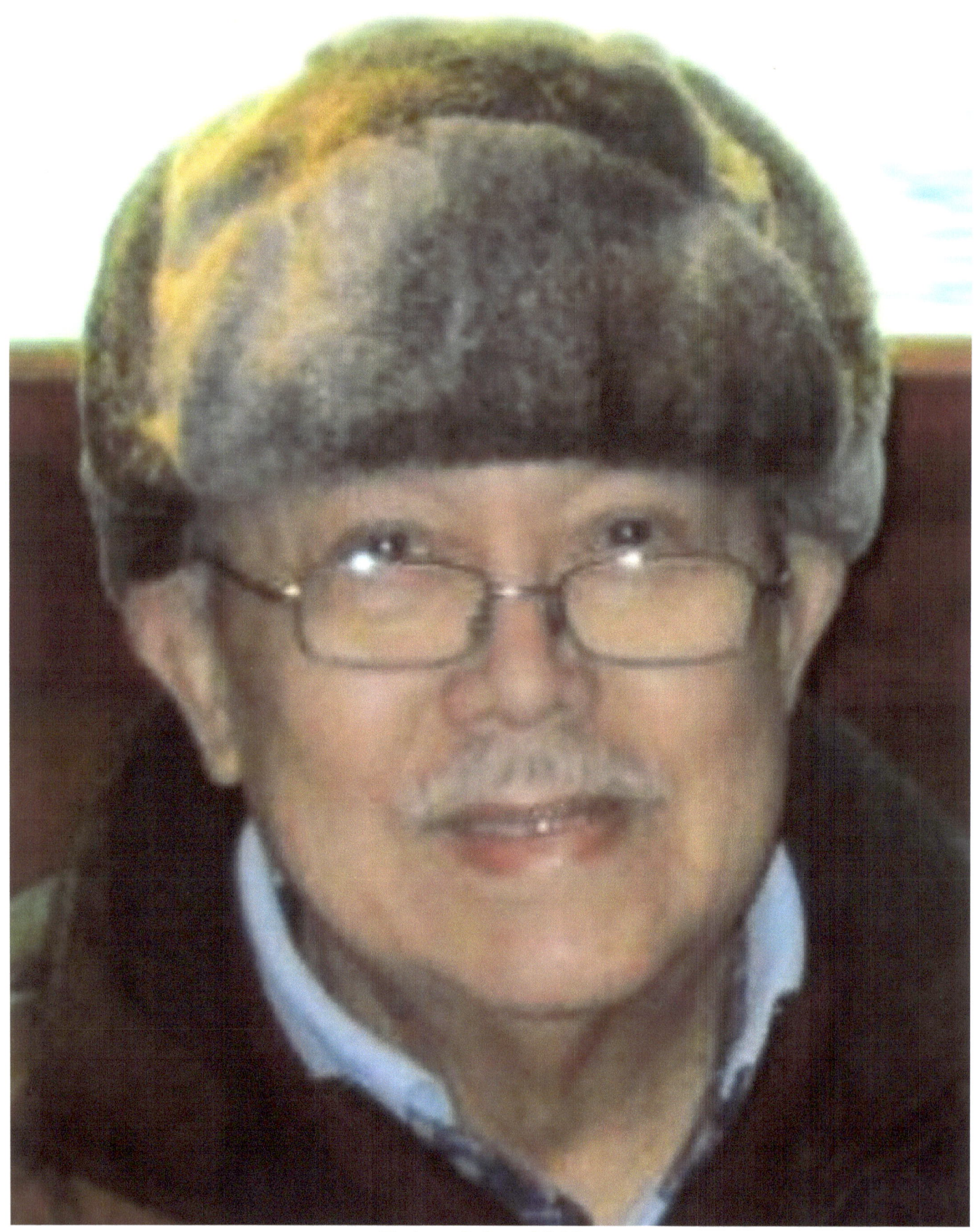

Tatay Jobo, 2010s

Portraits Album

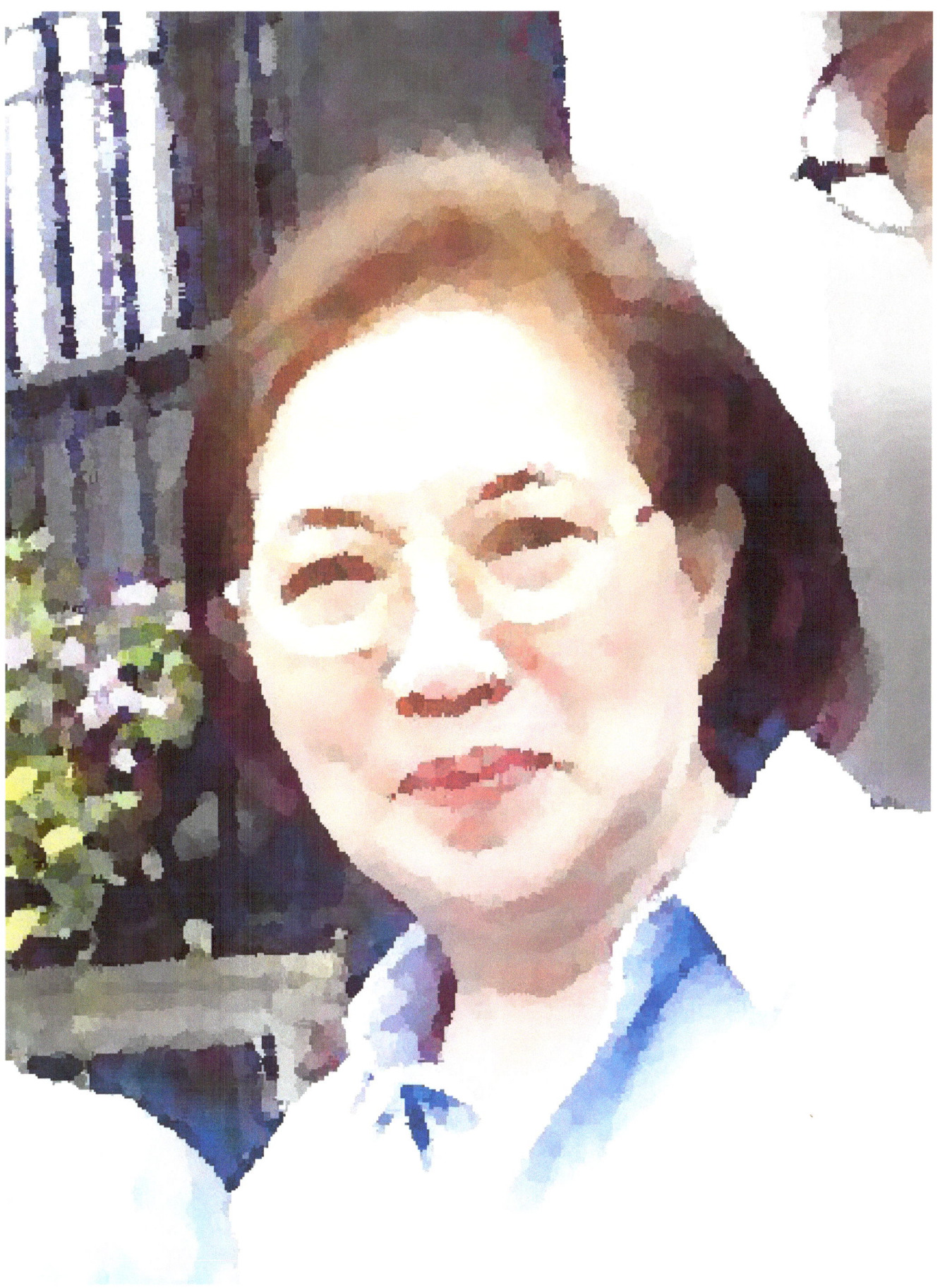

Nanay Cora, 1990s

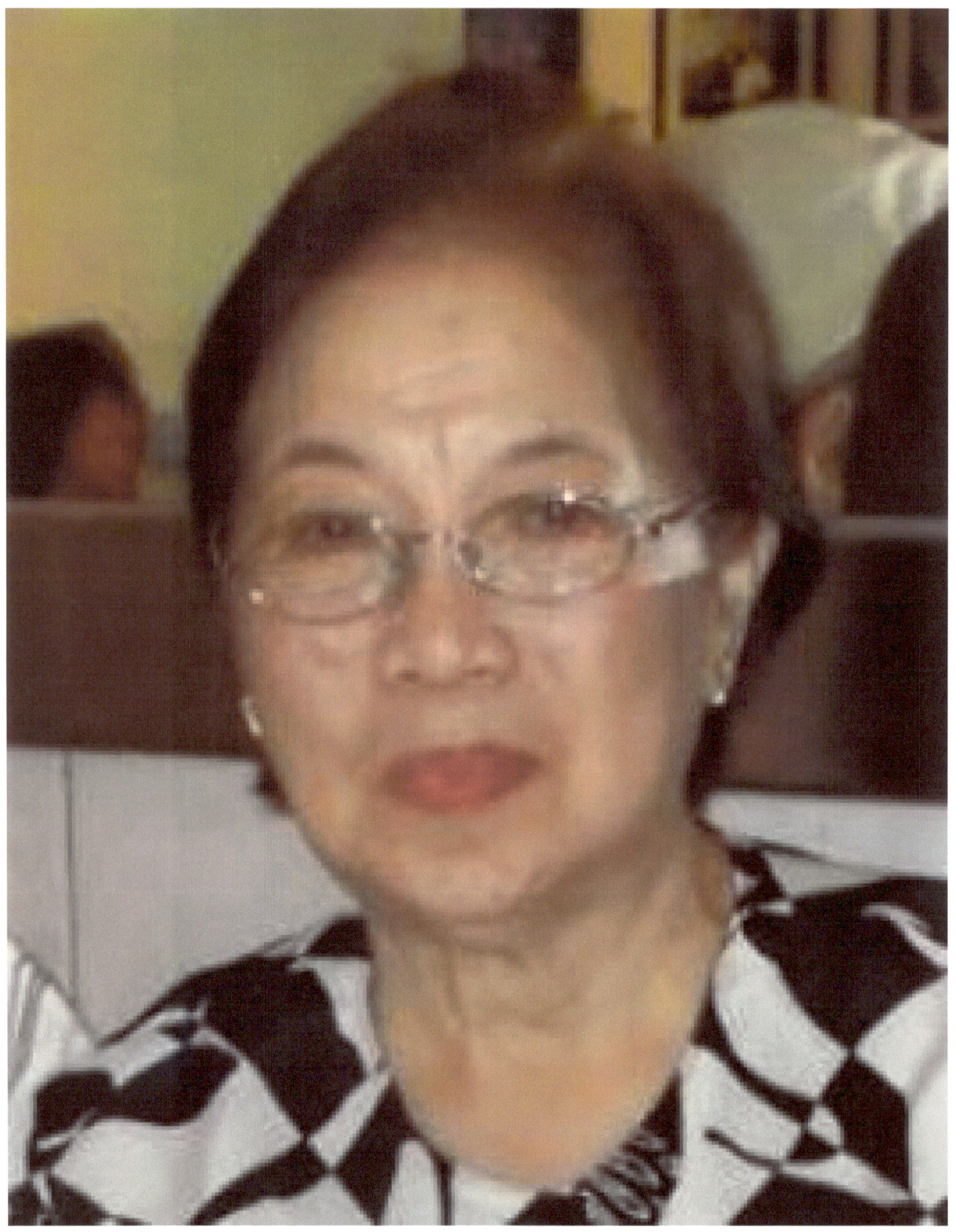

Nanay Cora, 2010s

Ester (Tetchie) Elizes Bowen

Portraits Album

Ester (Tetchie) Elizes Bowen

Portraits Album

Noelle Marie (Nowie) Elizes Bowen

Portraits Album

Noelle Mari (Nowie) Elizes Bowen

Portraits Album

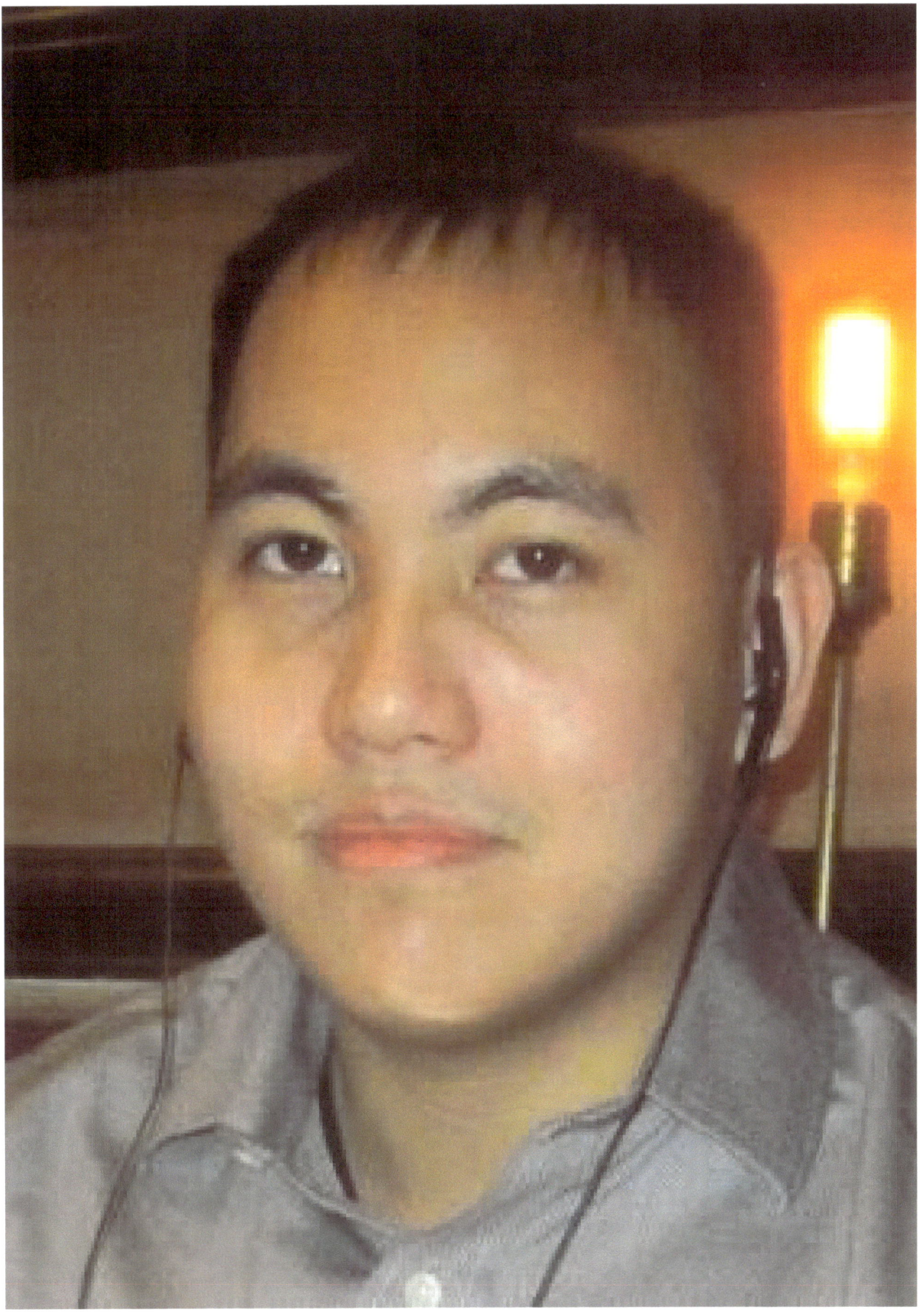

Jeb Elizes

Portraits Album

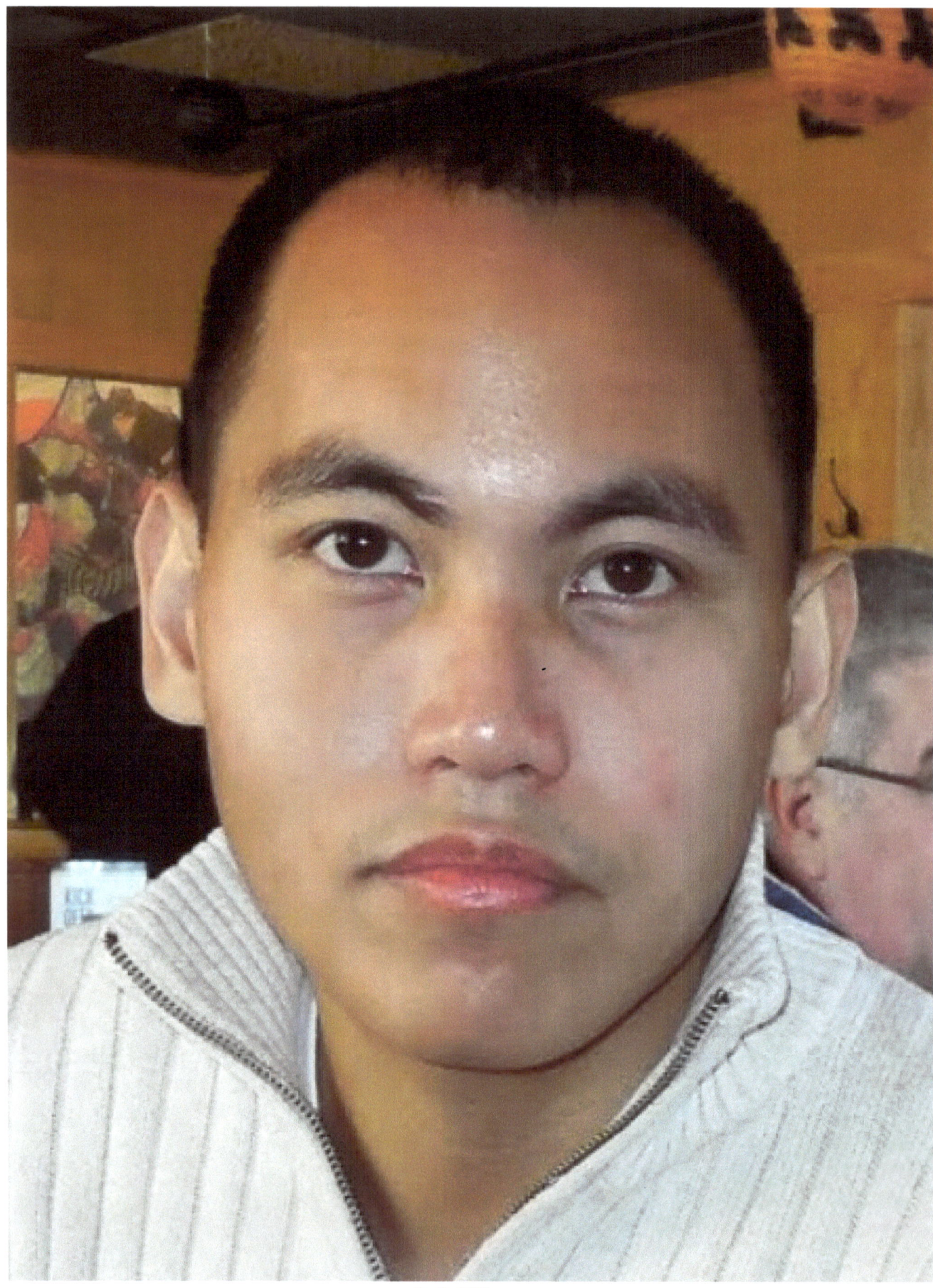

Jeb Elizes

Portraits Album

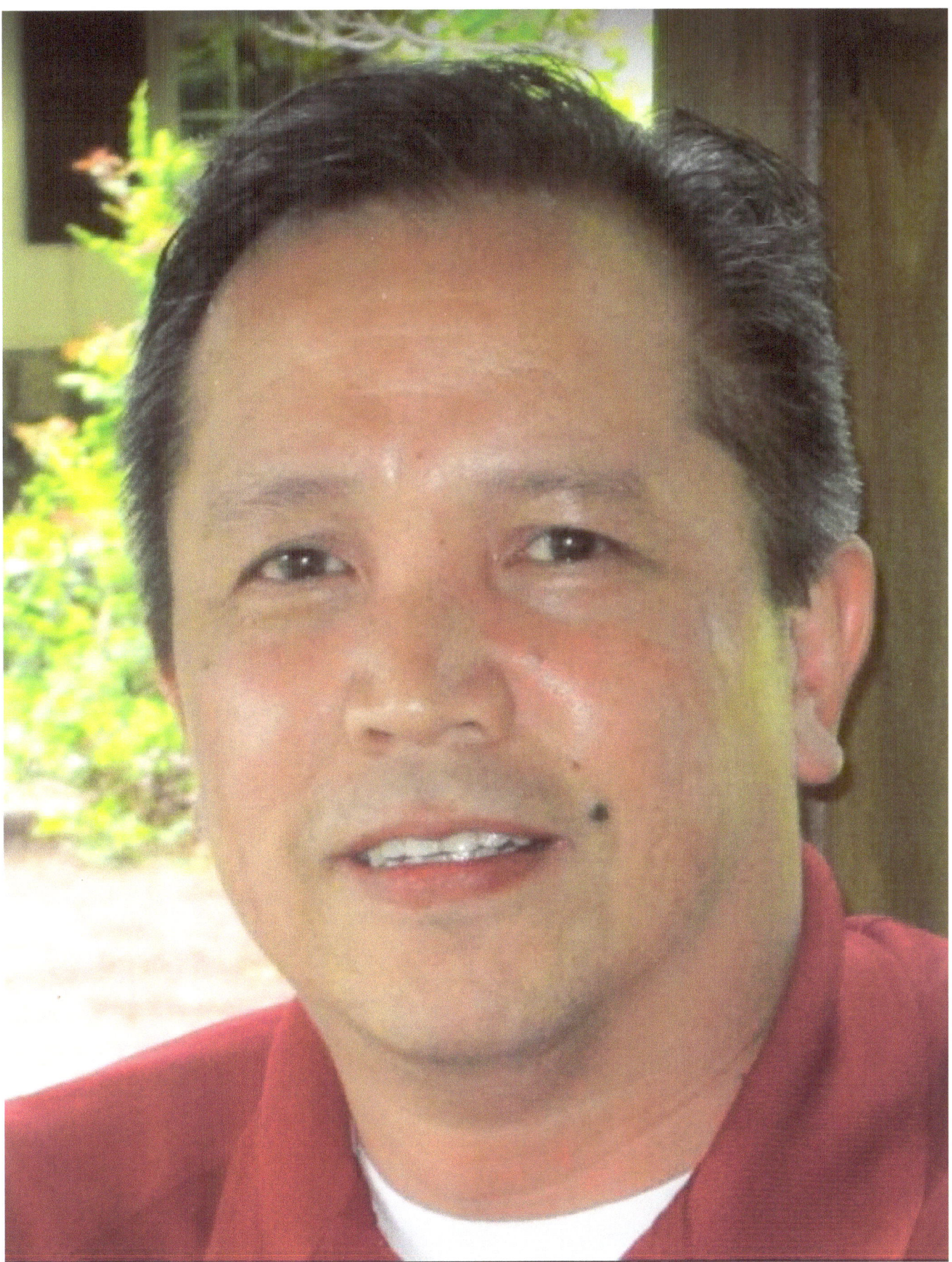

Chevalier (Chevy) Elizes

Portraits Album

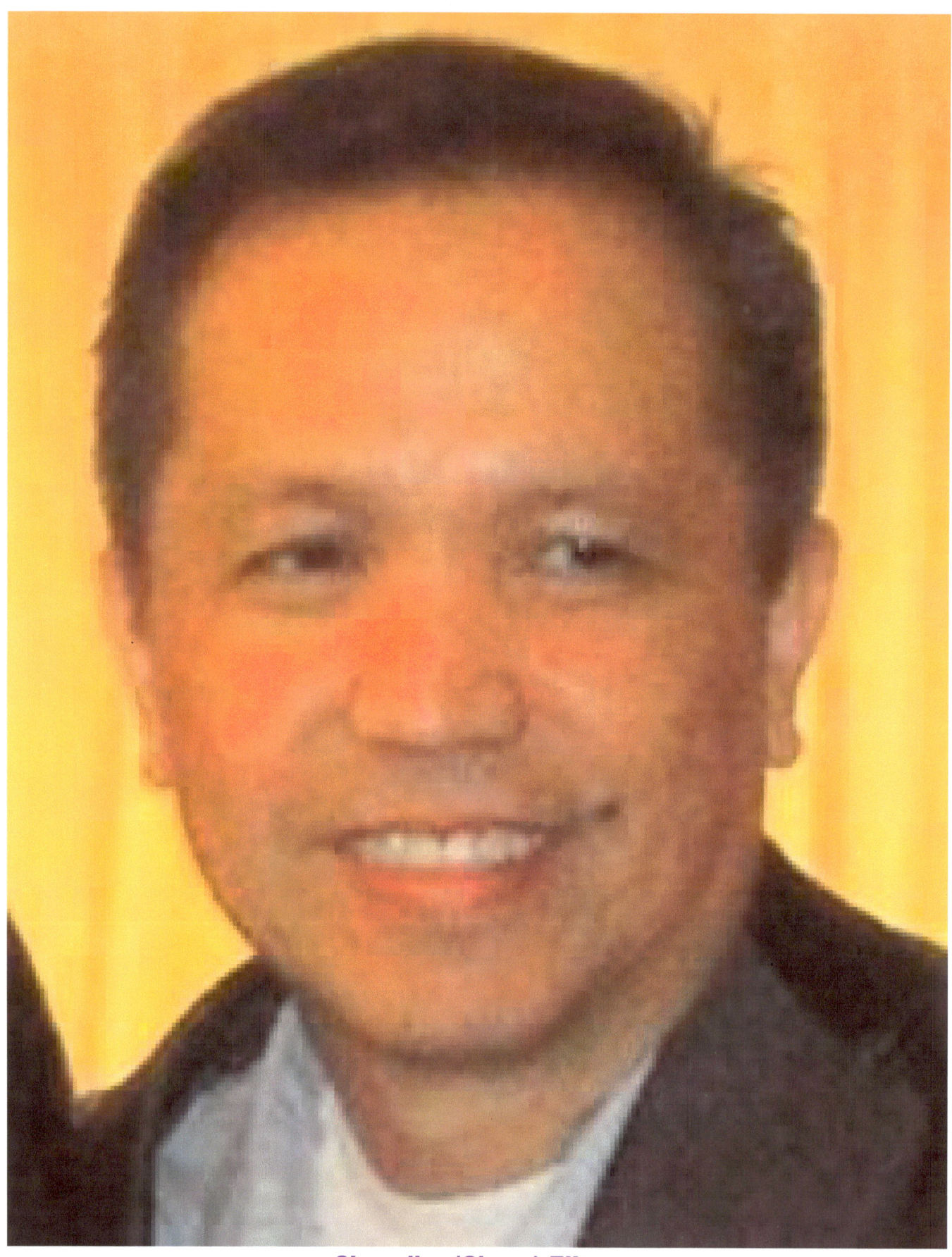

Chevalier (Chevy) Elizes

Portraits Album

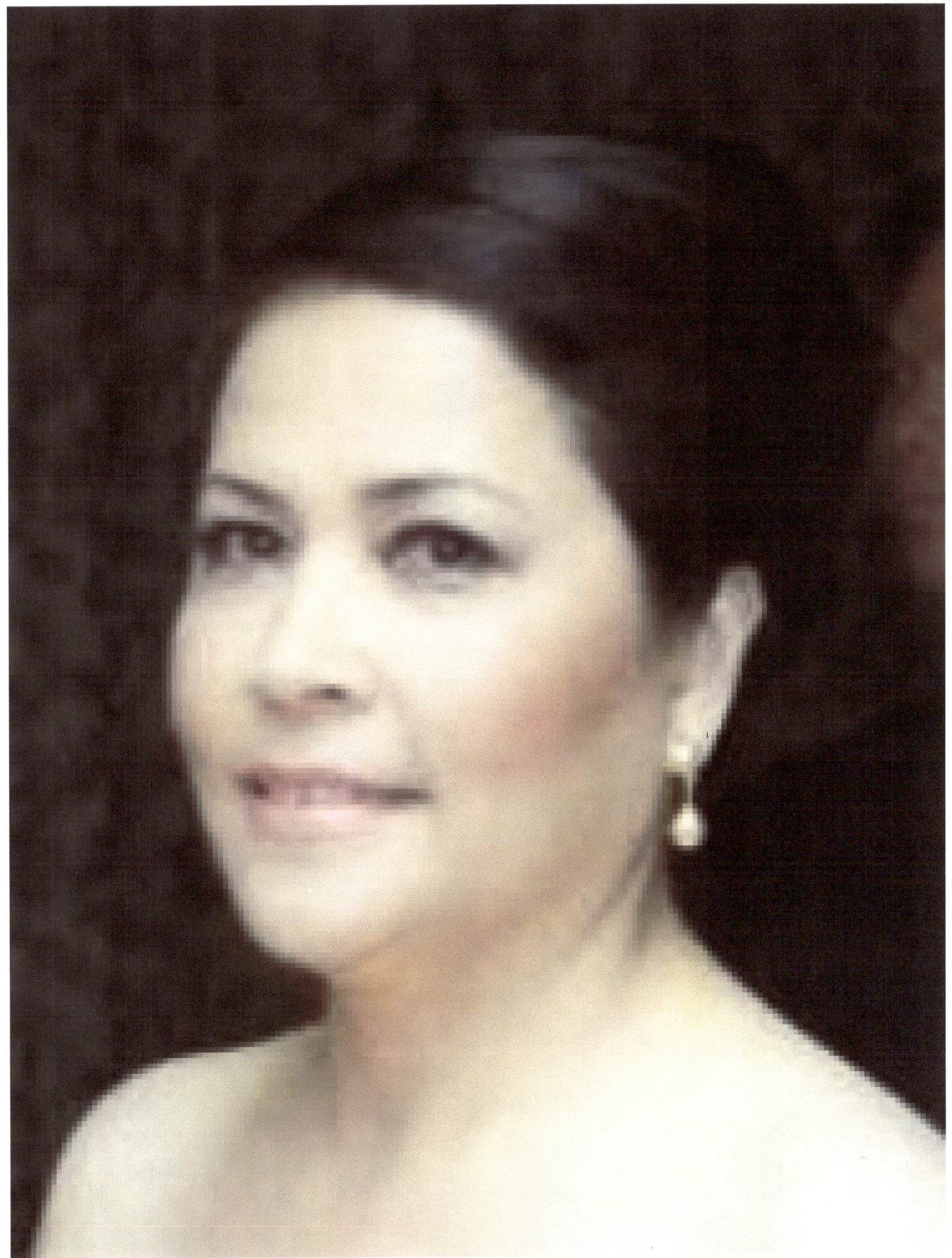

Elizabeth (Abaeth) Elizes

Portraits Album

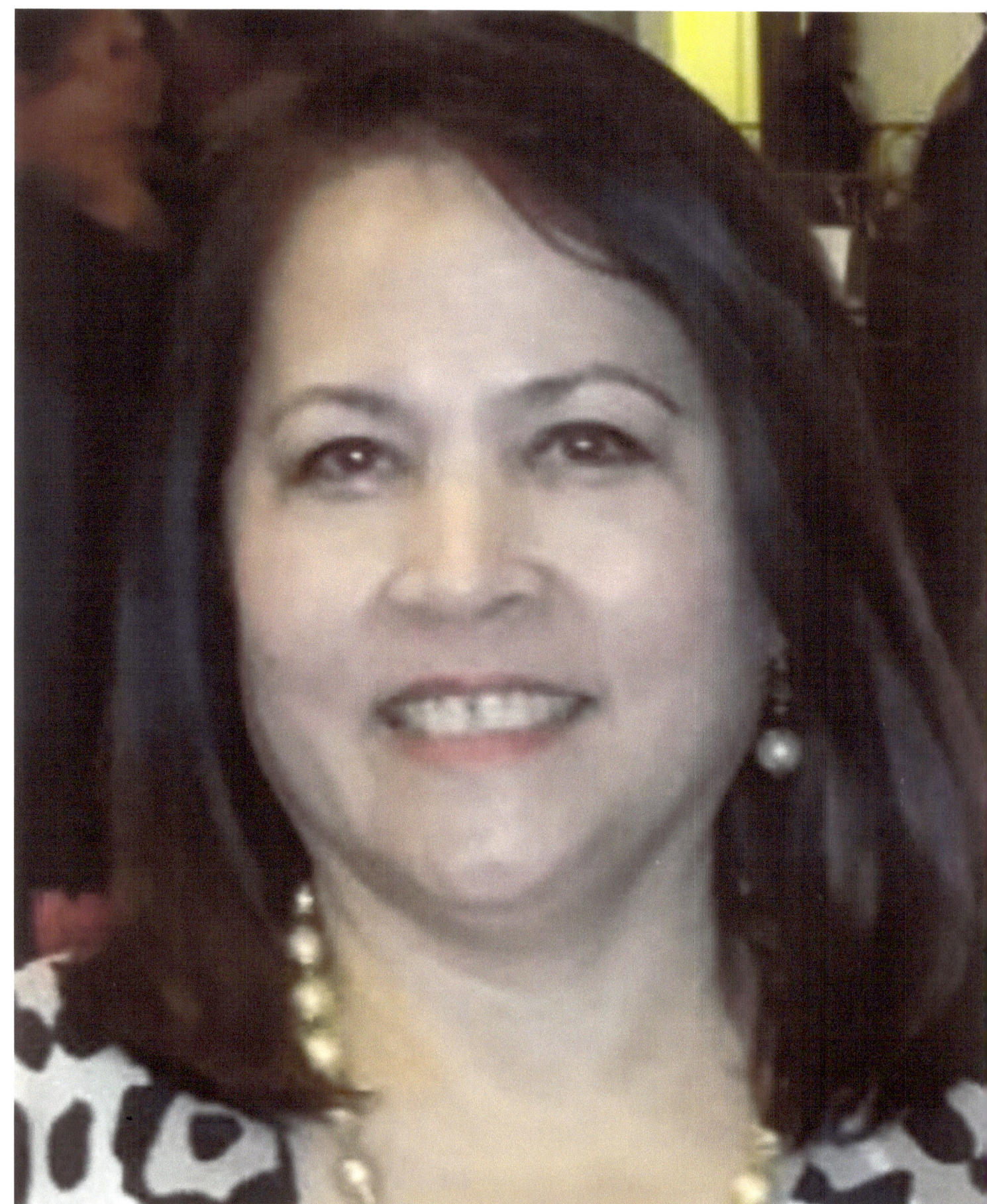

Elizabeth (Abeth) Elizes

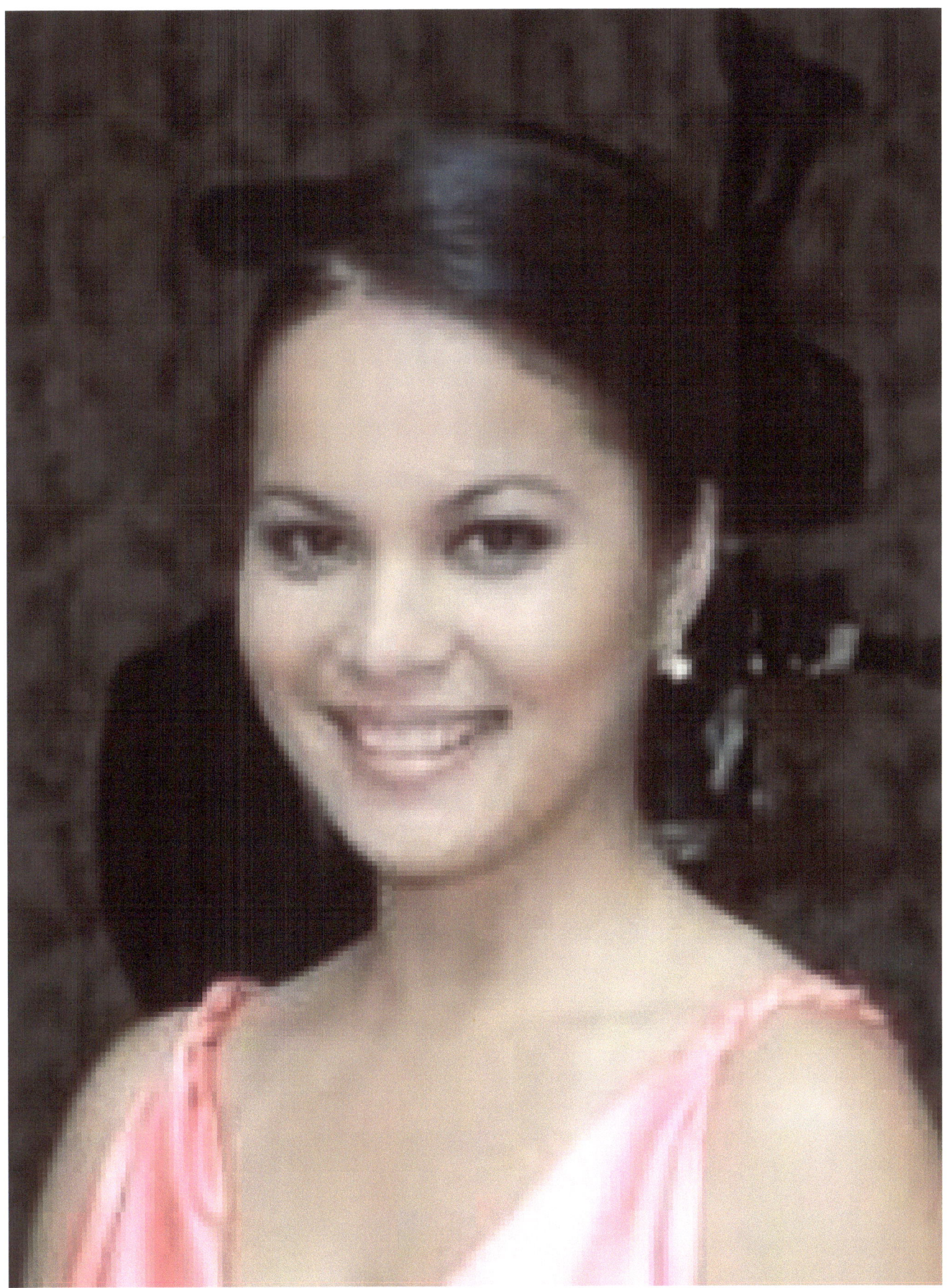

Karines (Karin) Elizes Mra

Portraits Album

Karines (Karin) Elizes Mra

Portraits Album

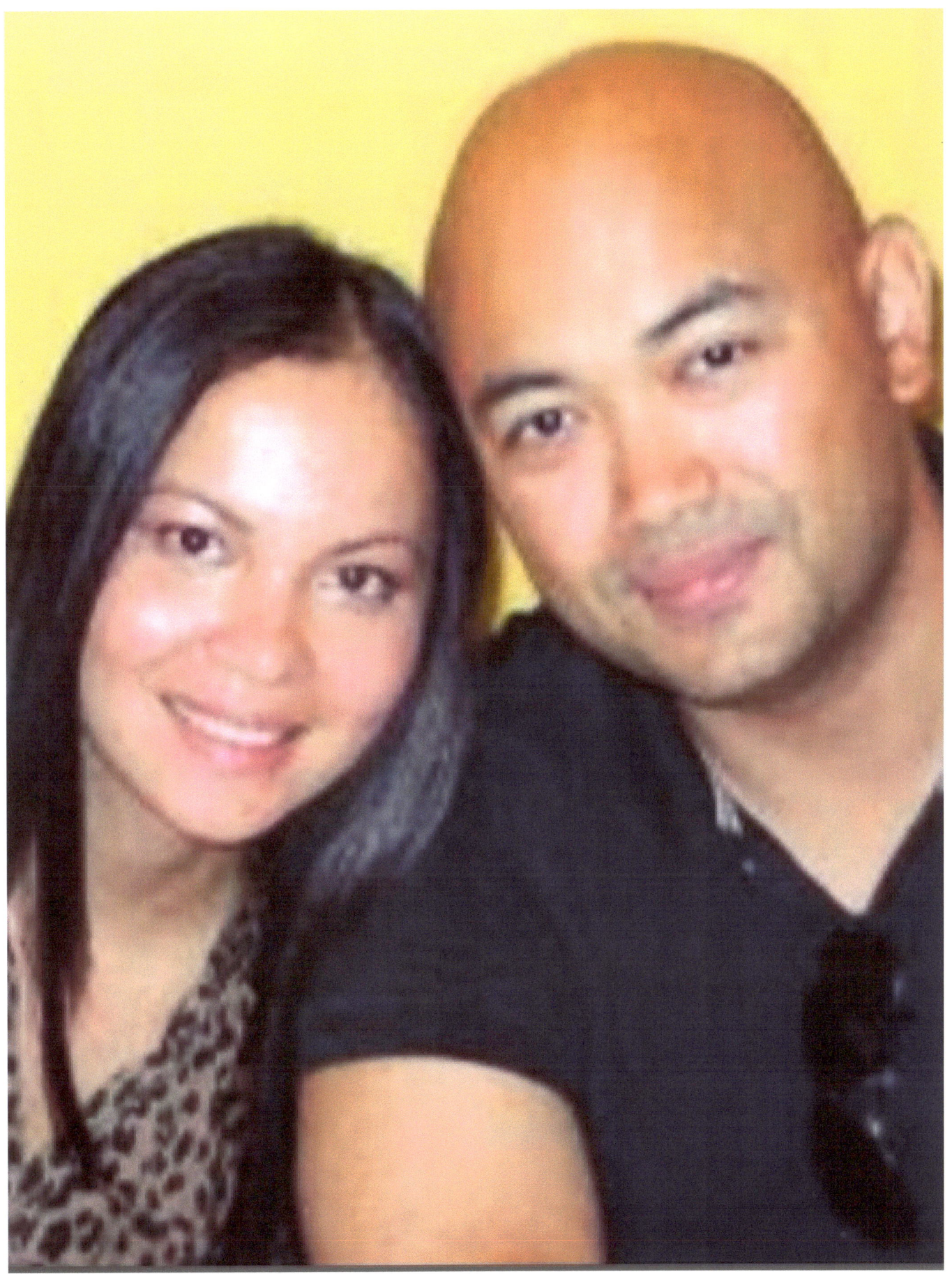

Karines & Aung Mra

Portraits Album

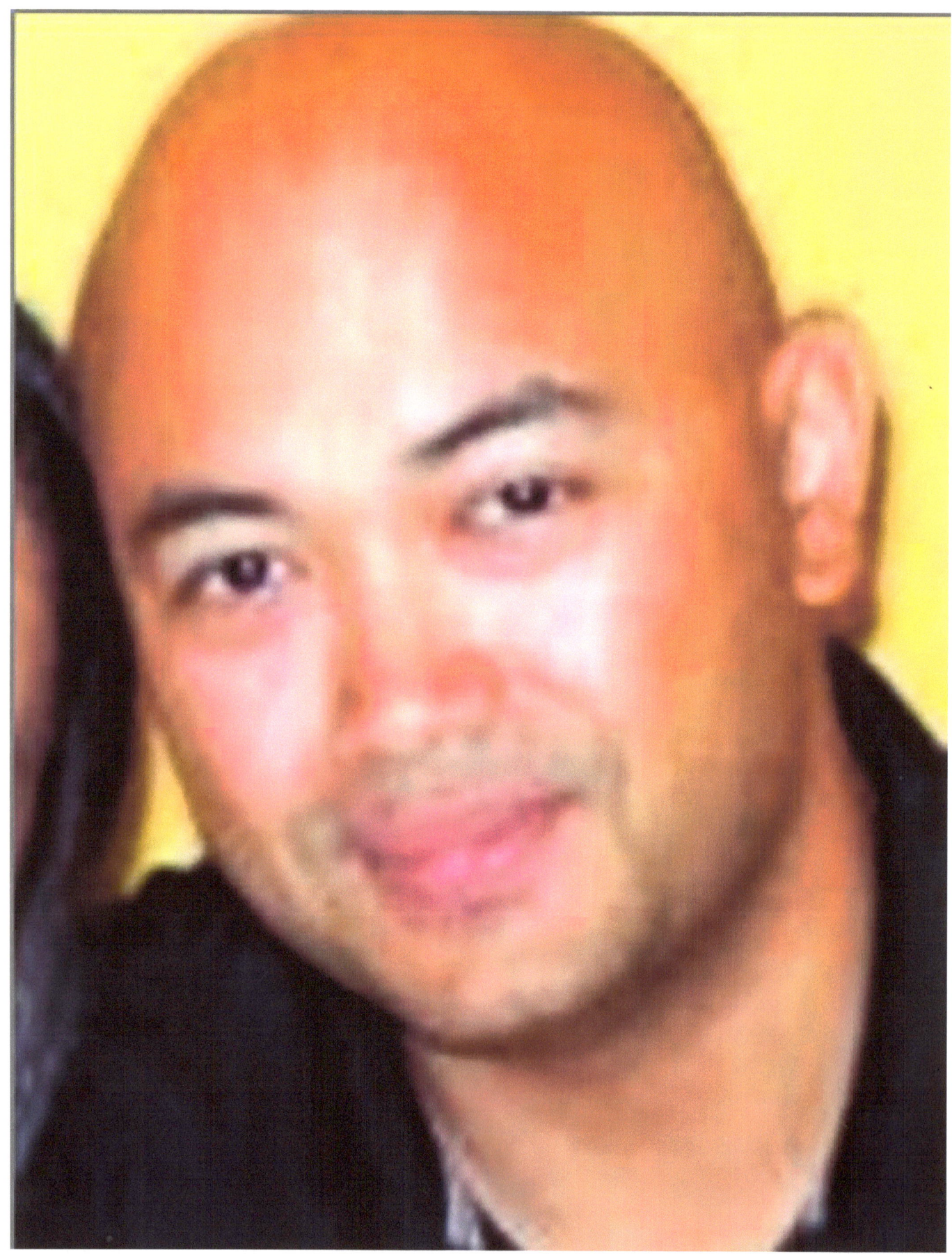

Aung Mra

Portraits Album

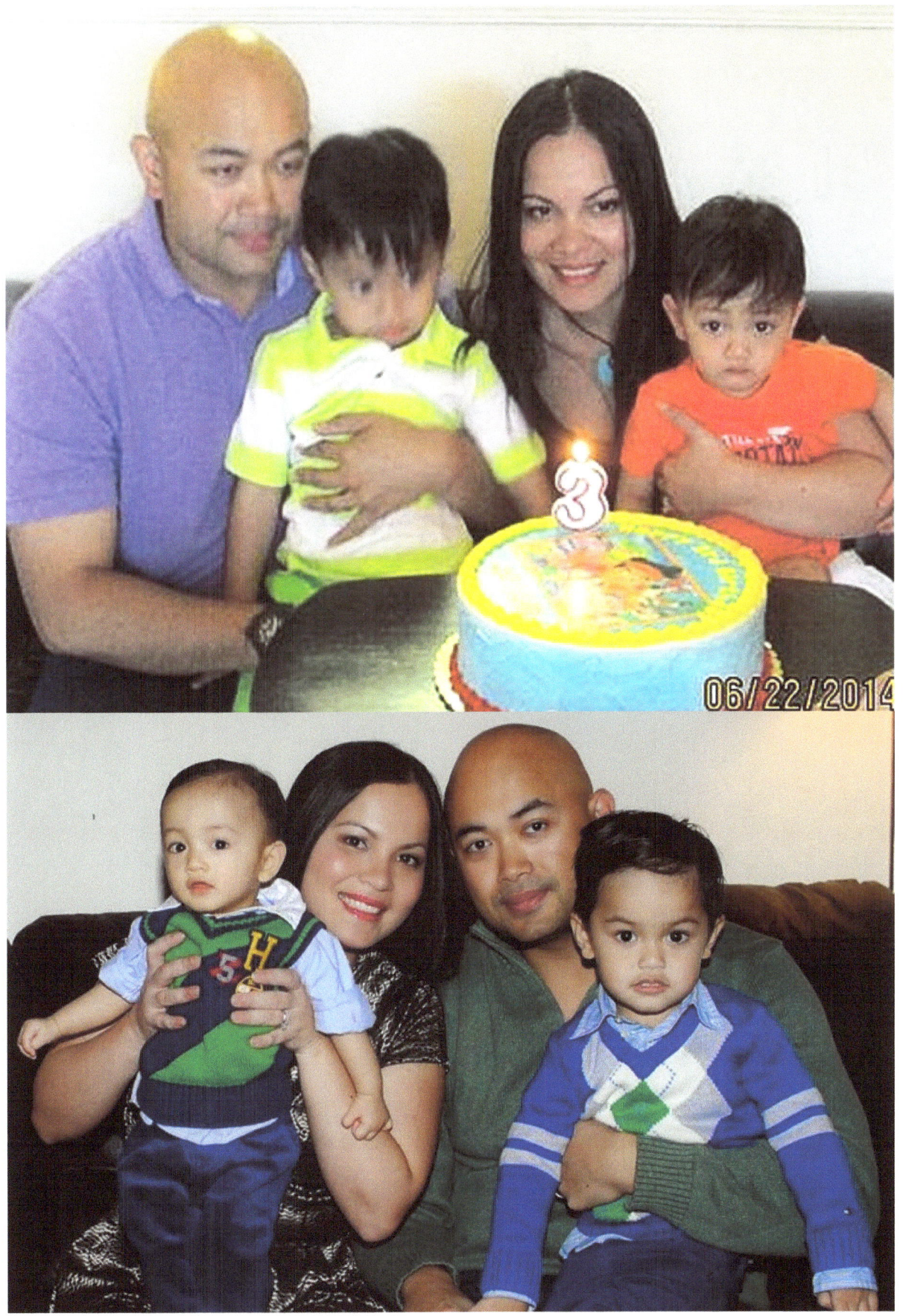

Sons Jason and Carson with parents Karin & Aung Mra

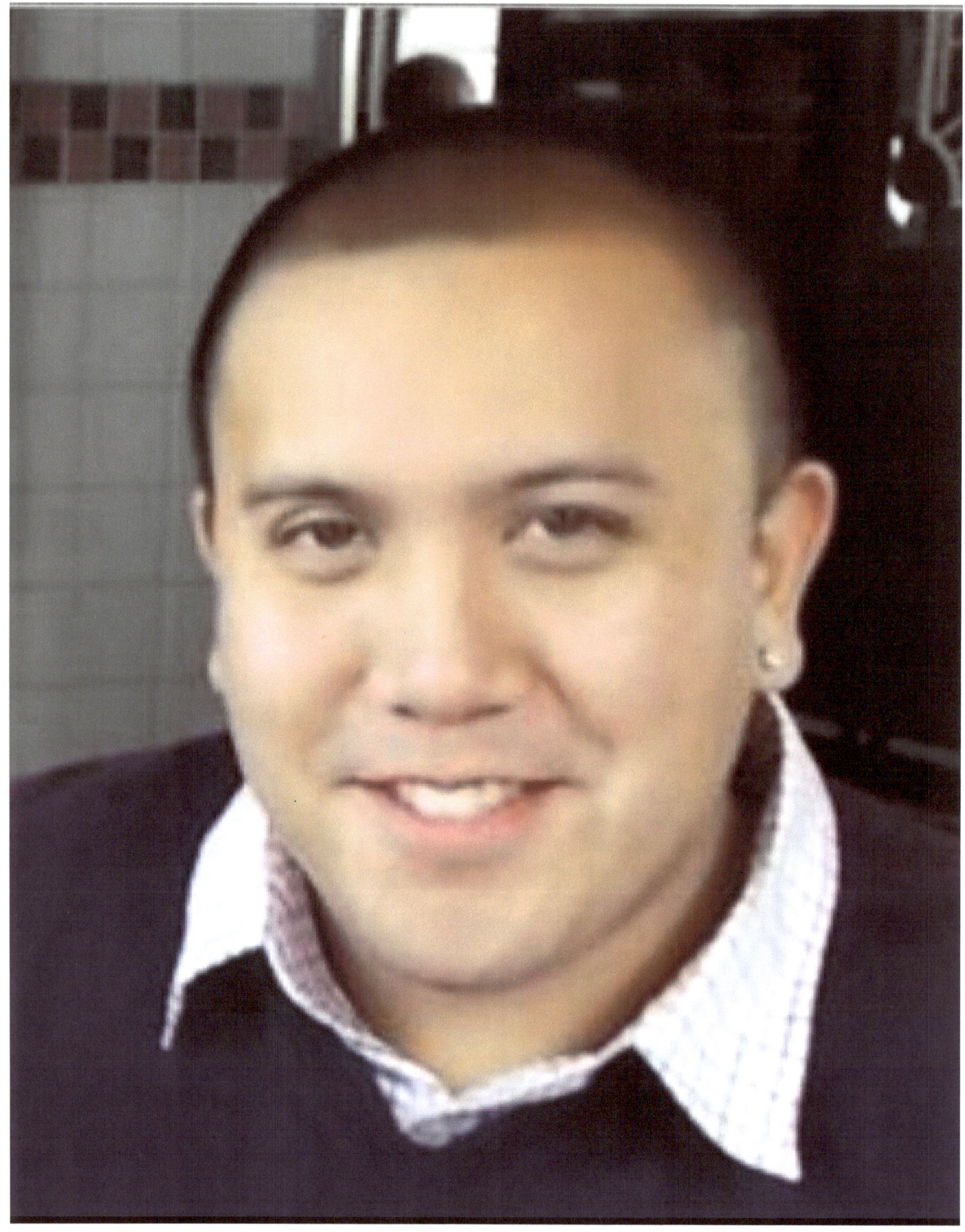

Chad Elizes

Chad Elizes

Christy Reyes

Christy Reyes

Portraits Album

Marinela (Marie) Elizes Reyes. (R.I.P.)

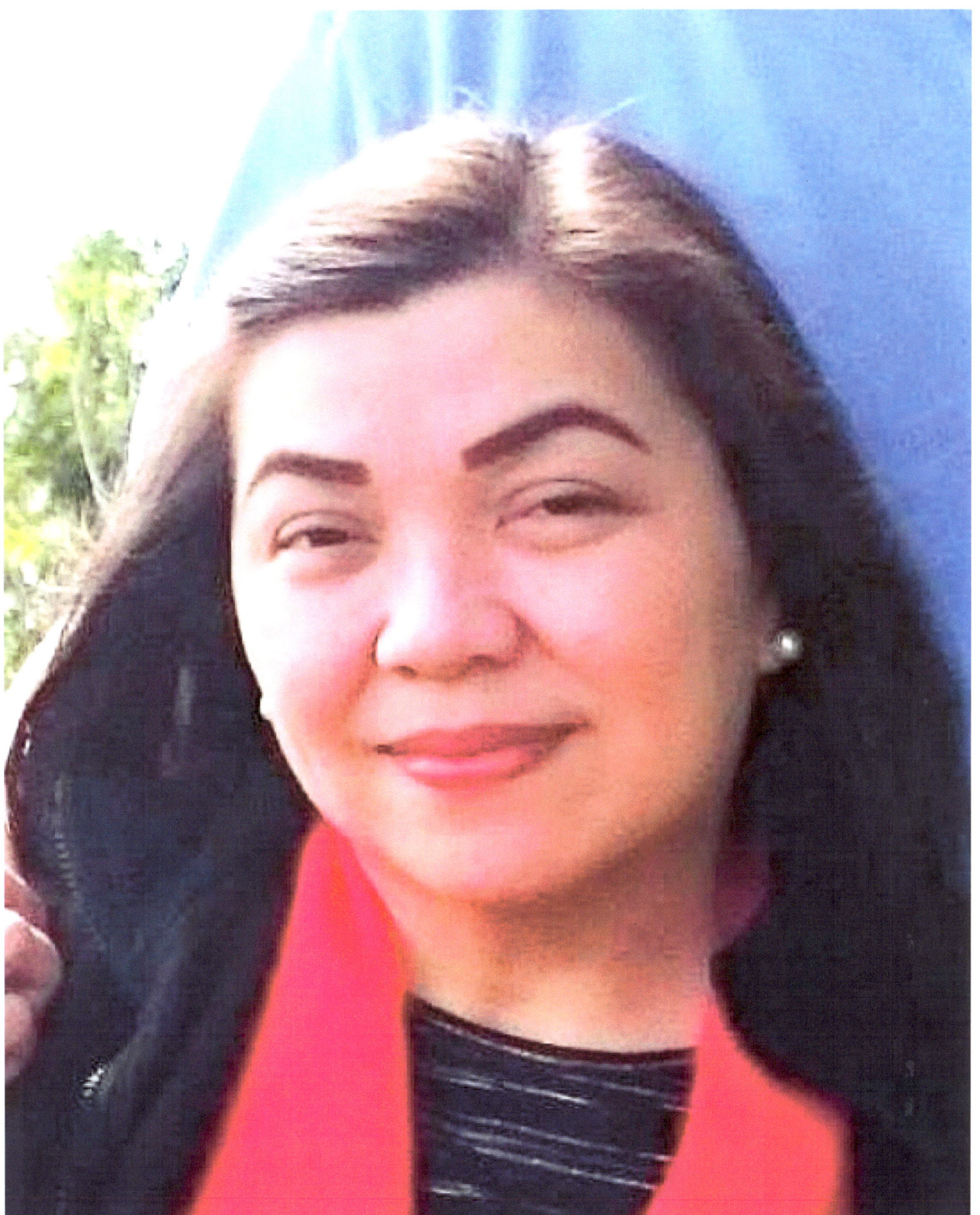

Marinela (Marie) Elizes Reyes, (R.I.P.)

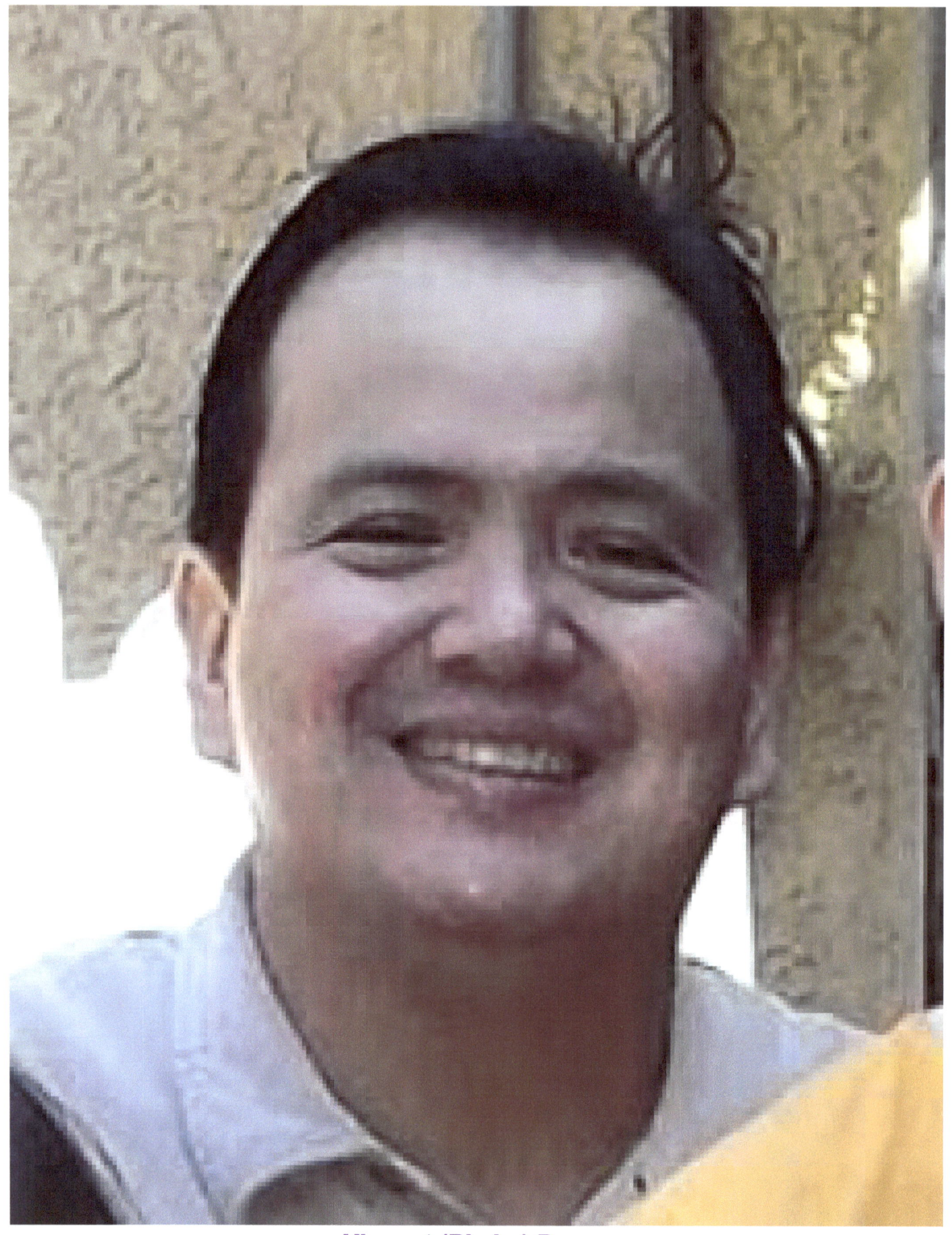

Vincent (Bimbo) Reyes

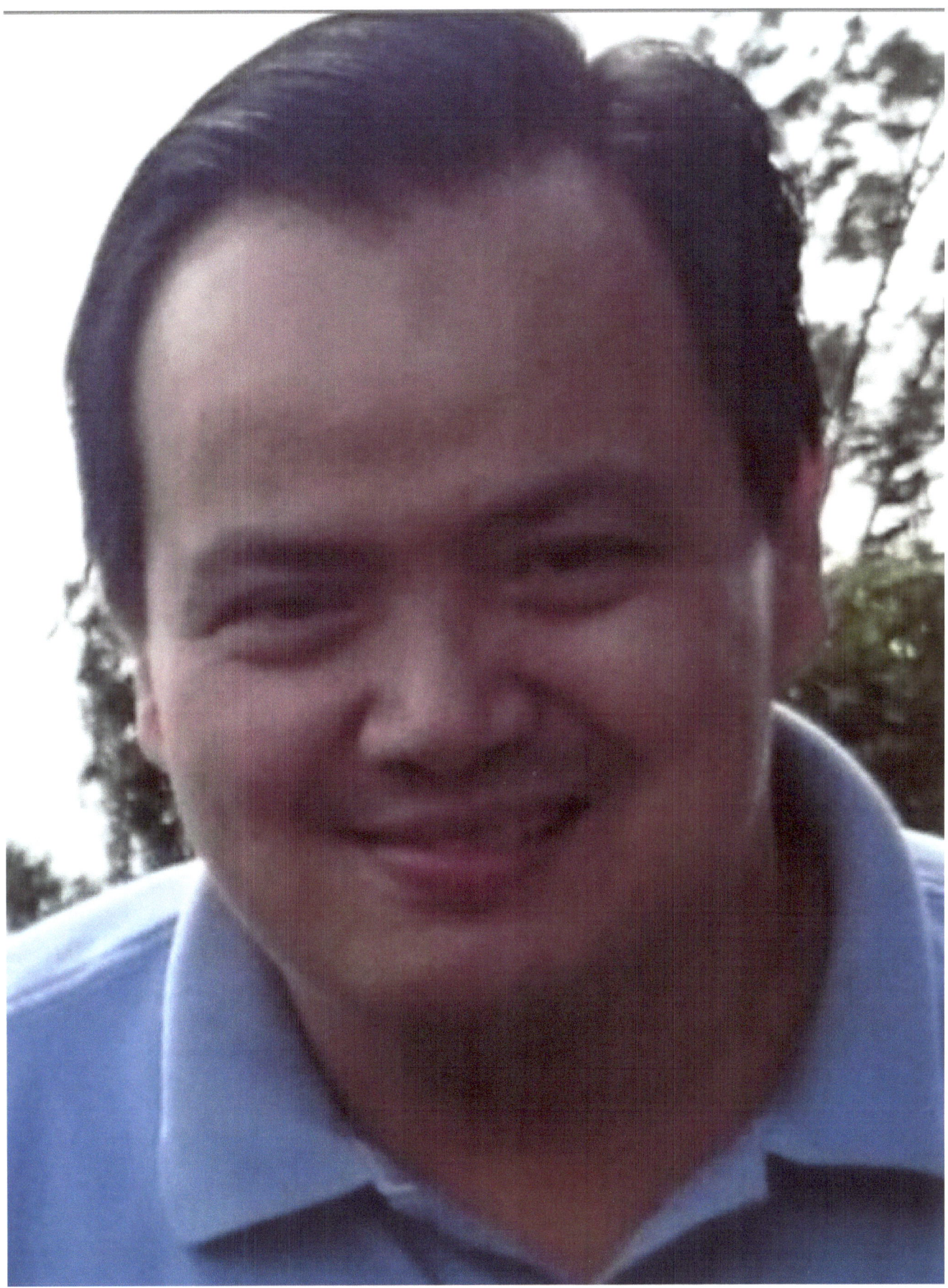

Vincent (Bimbo) Reyes

Portraits Album

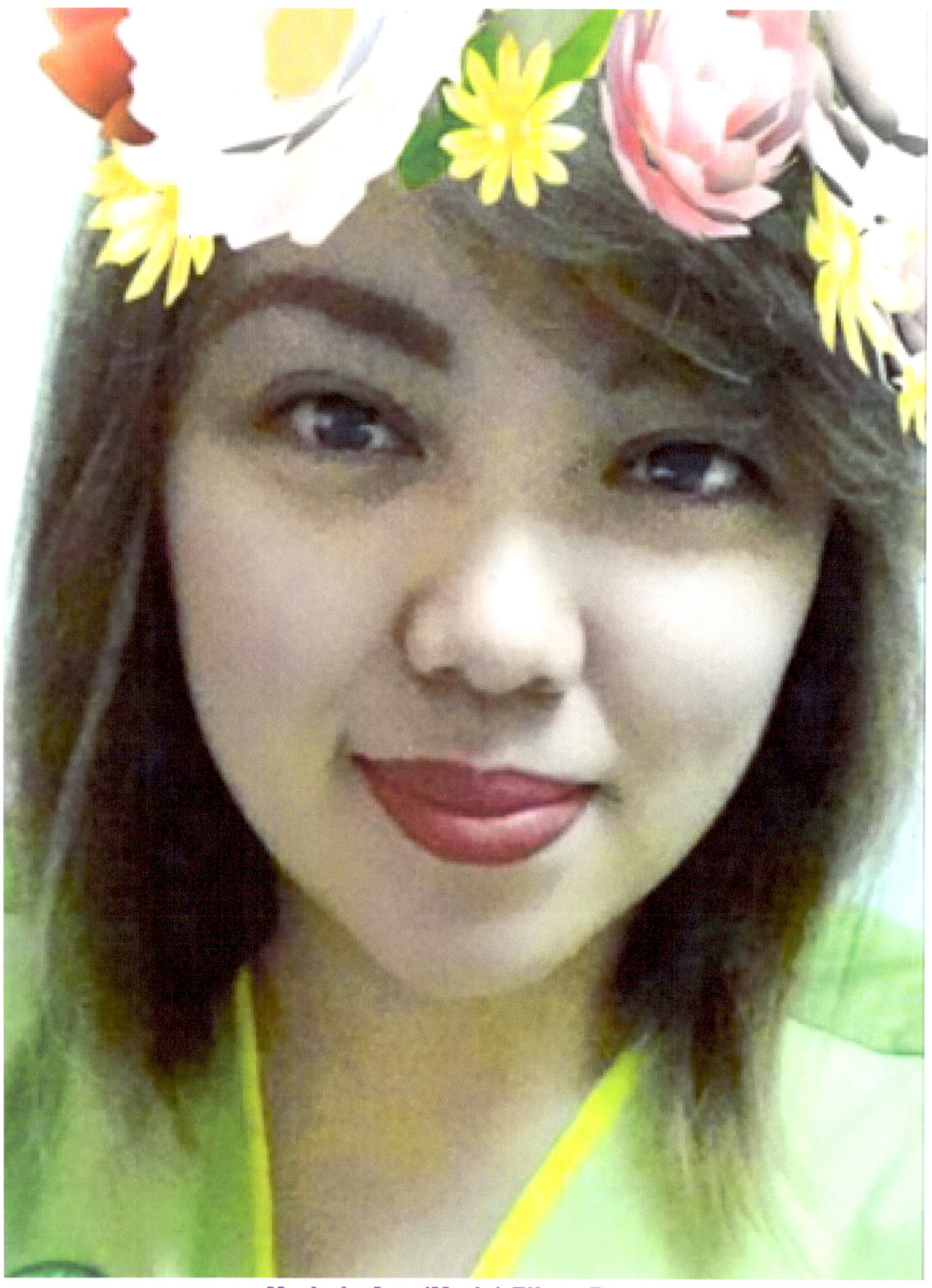

Marjorie Ann (Marjo) Elizes Reyes

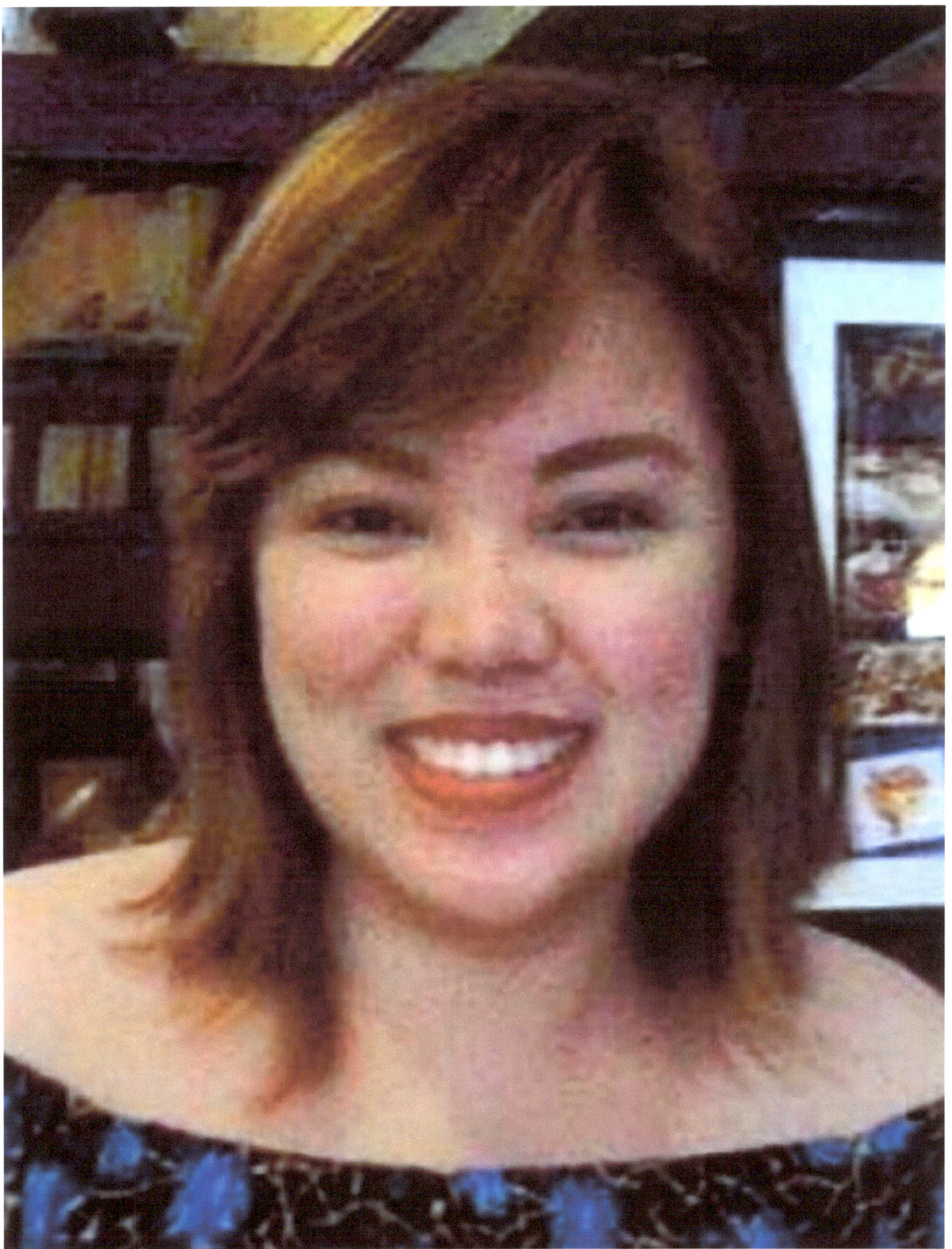

Marjorie Ann (Marjo) Elizes Reyes

Portraits Album

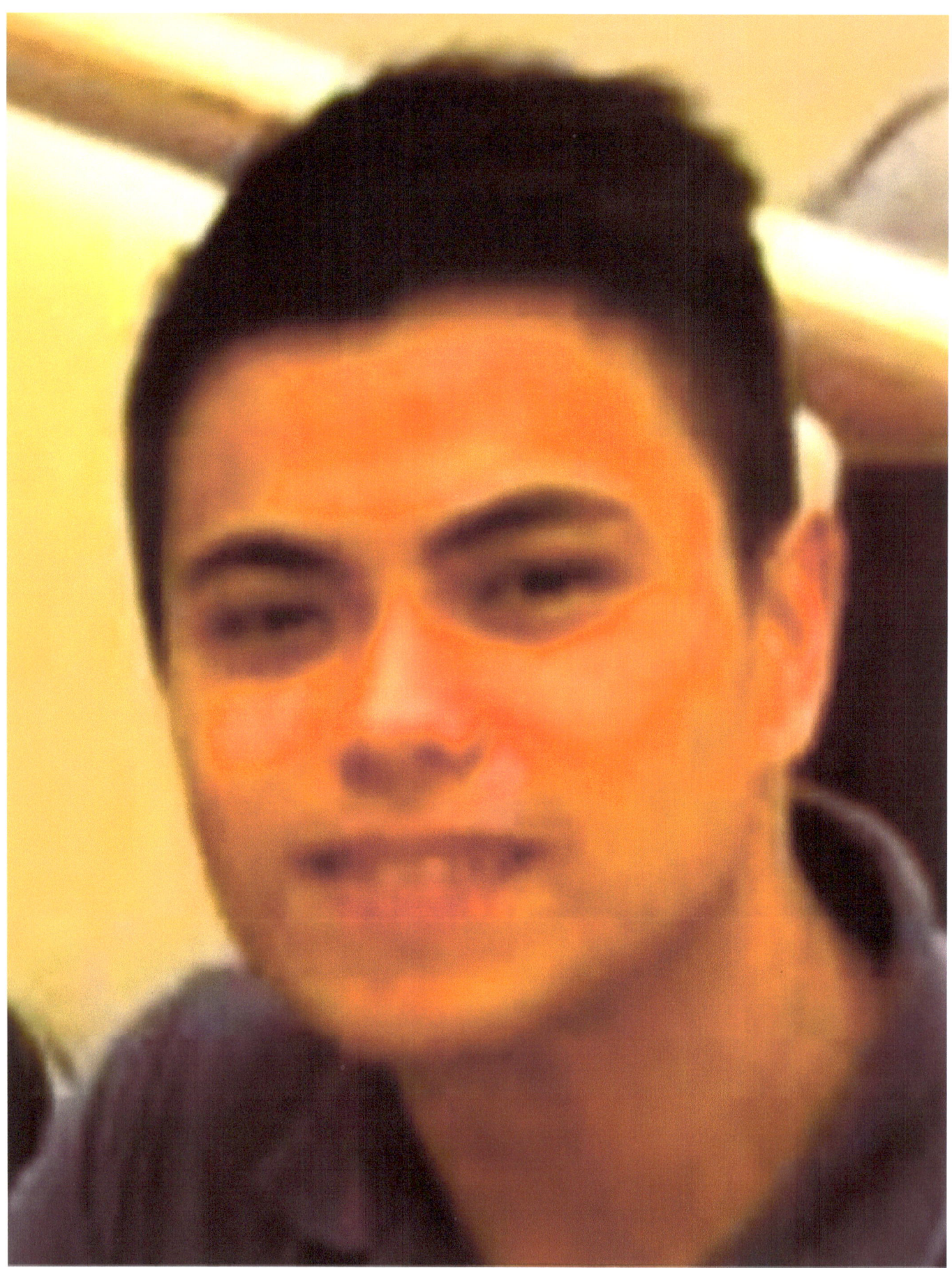

Marvin Elizes Reyes

Portraits Album

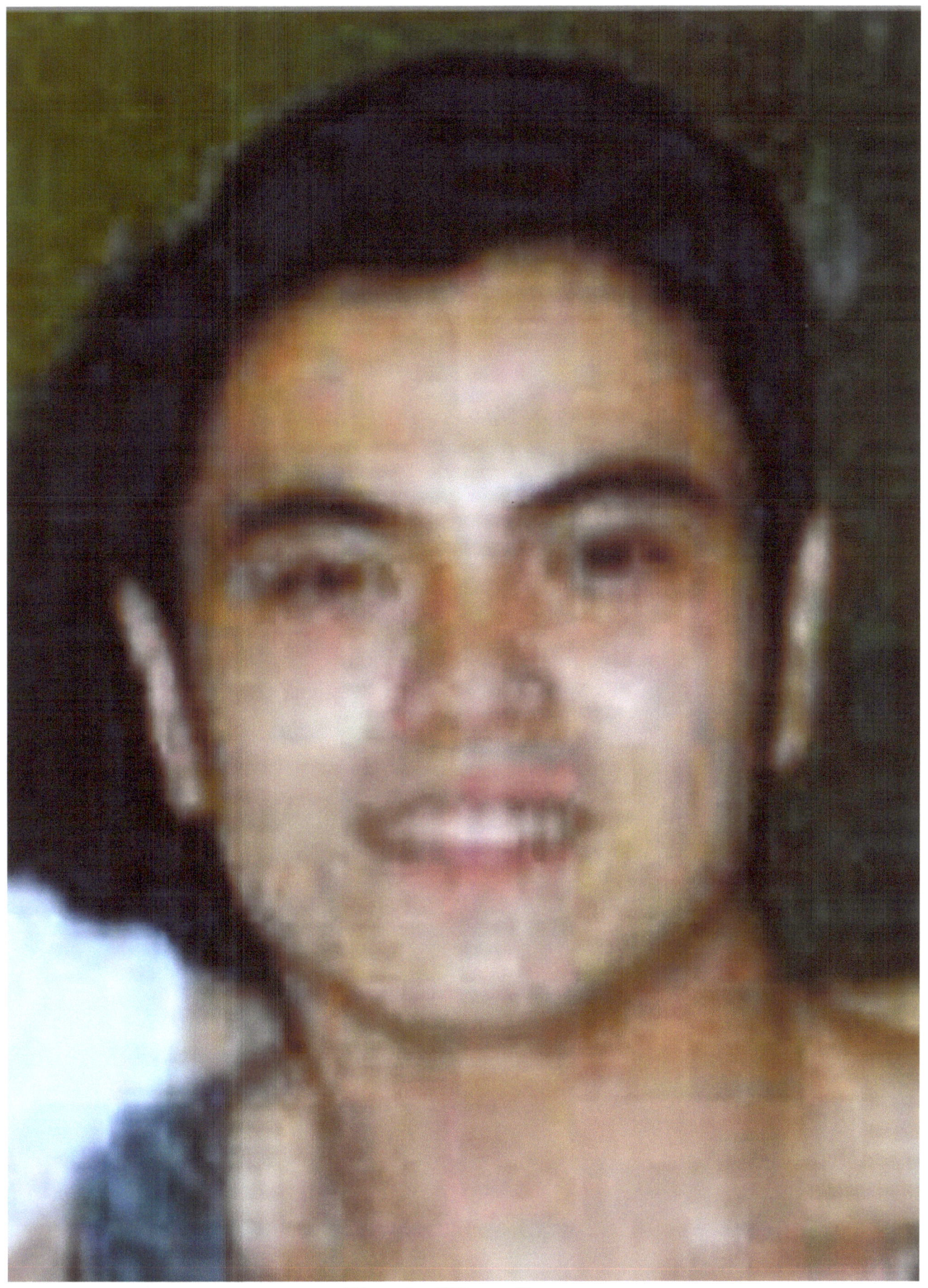

Marvin Elizes Reyes

Portraits Album

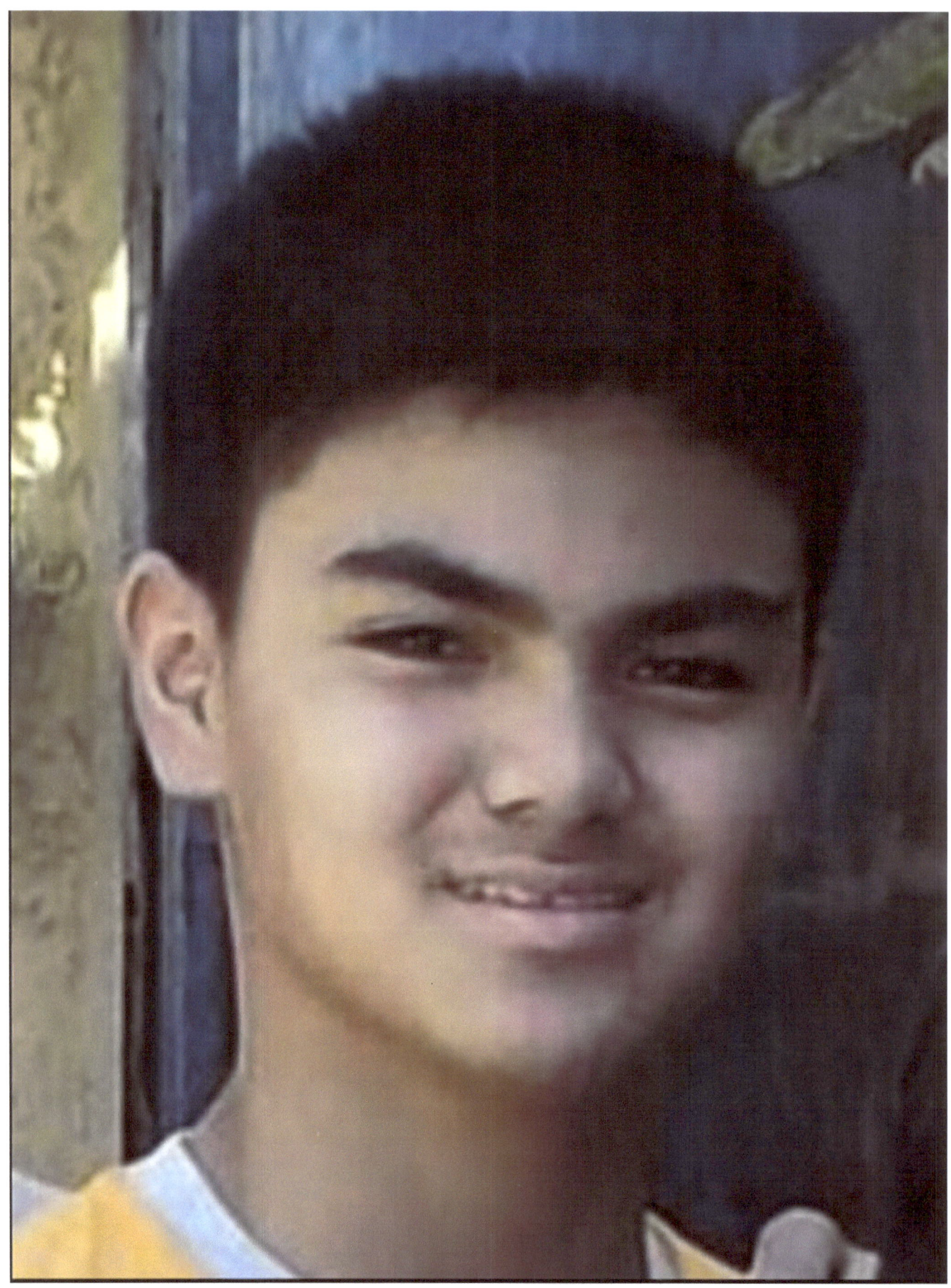

Marty Elizes Reyes

Portraits Album

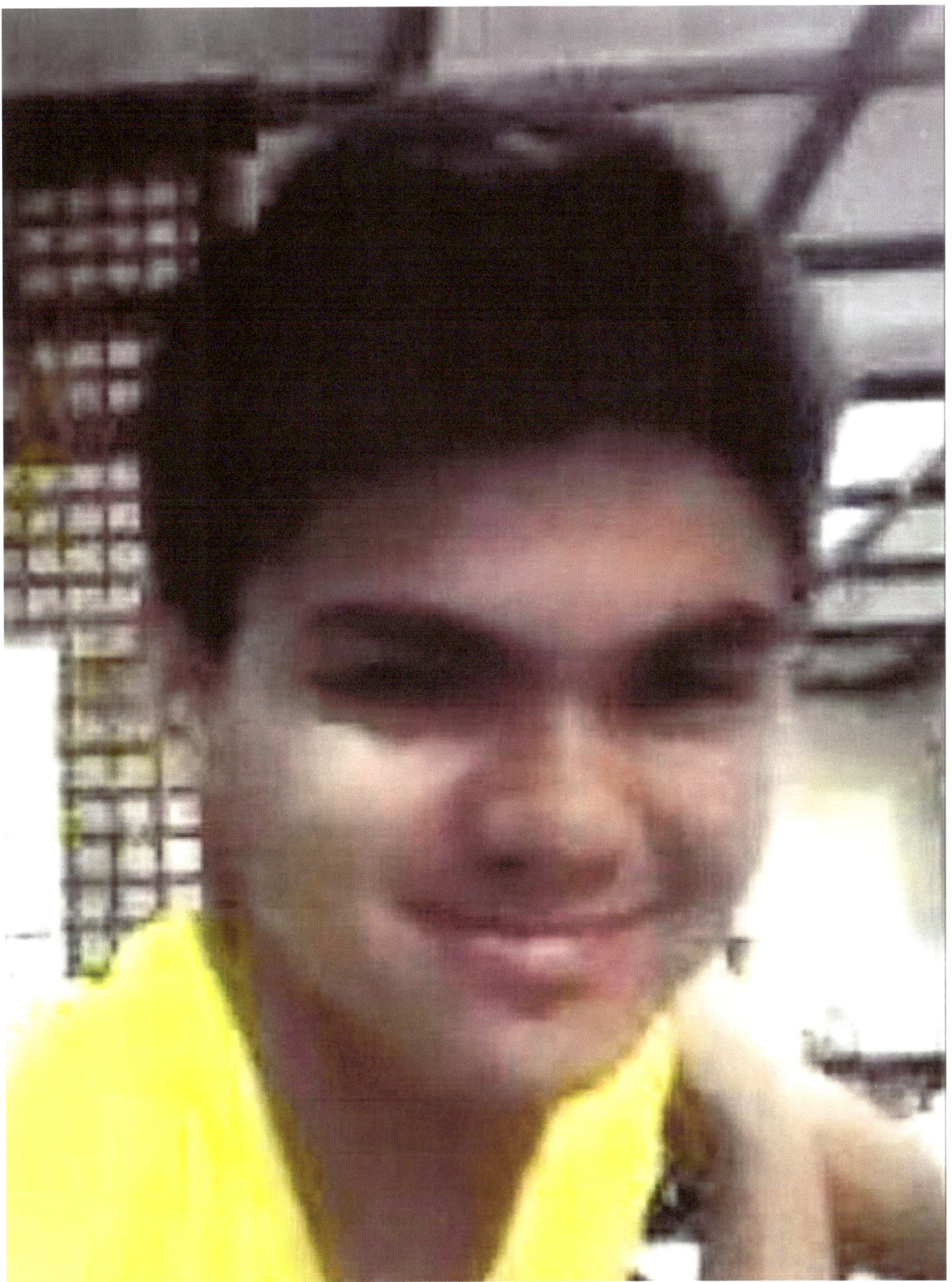

Marty (Federer) Elizes Reyes

Portraits Album

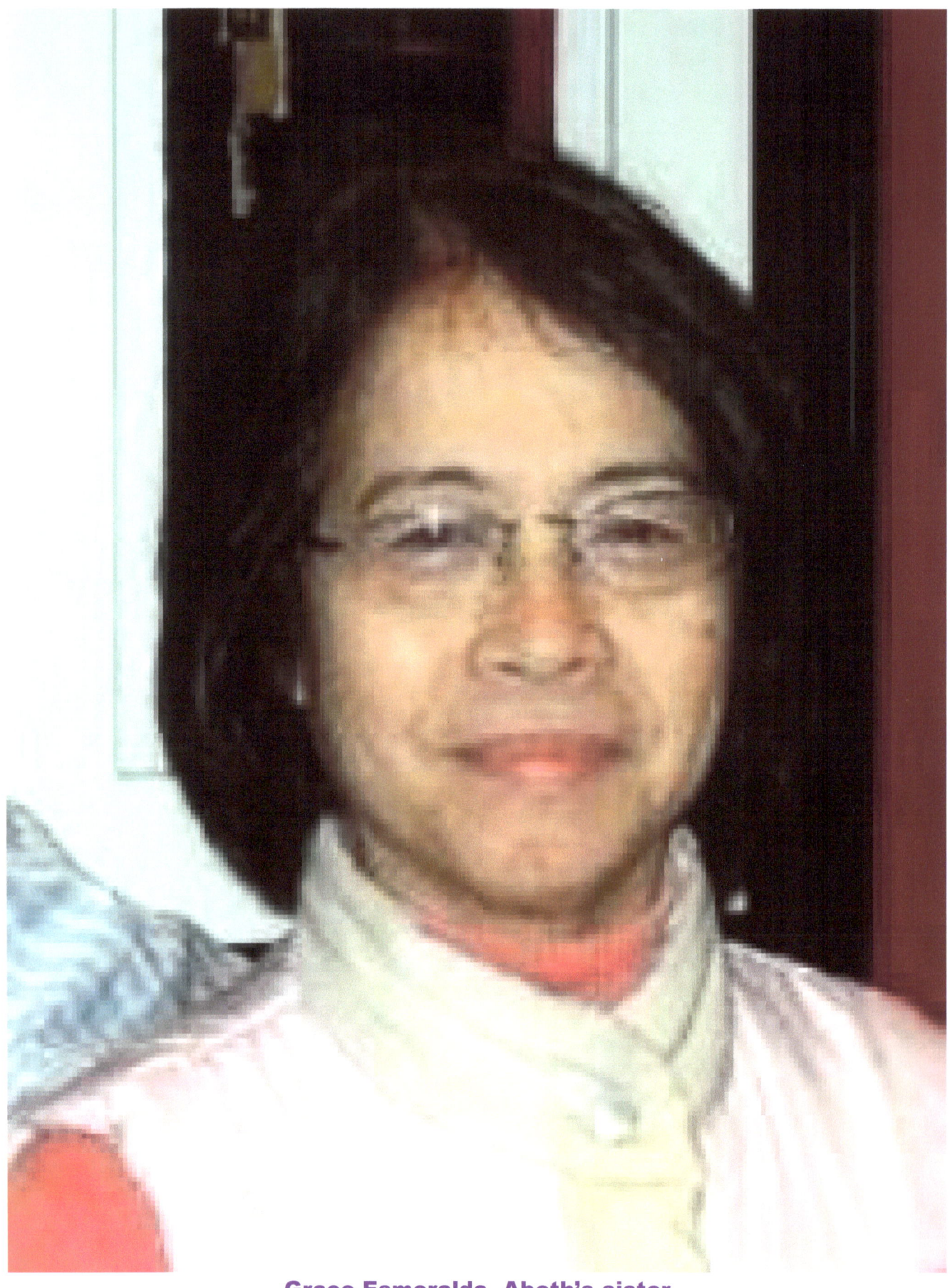

Grace Esmeralda, Abeth's sister

Portraits Album

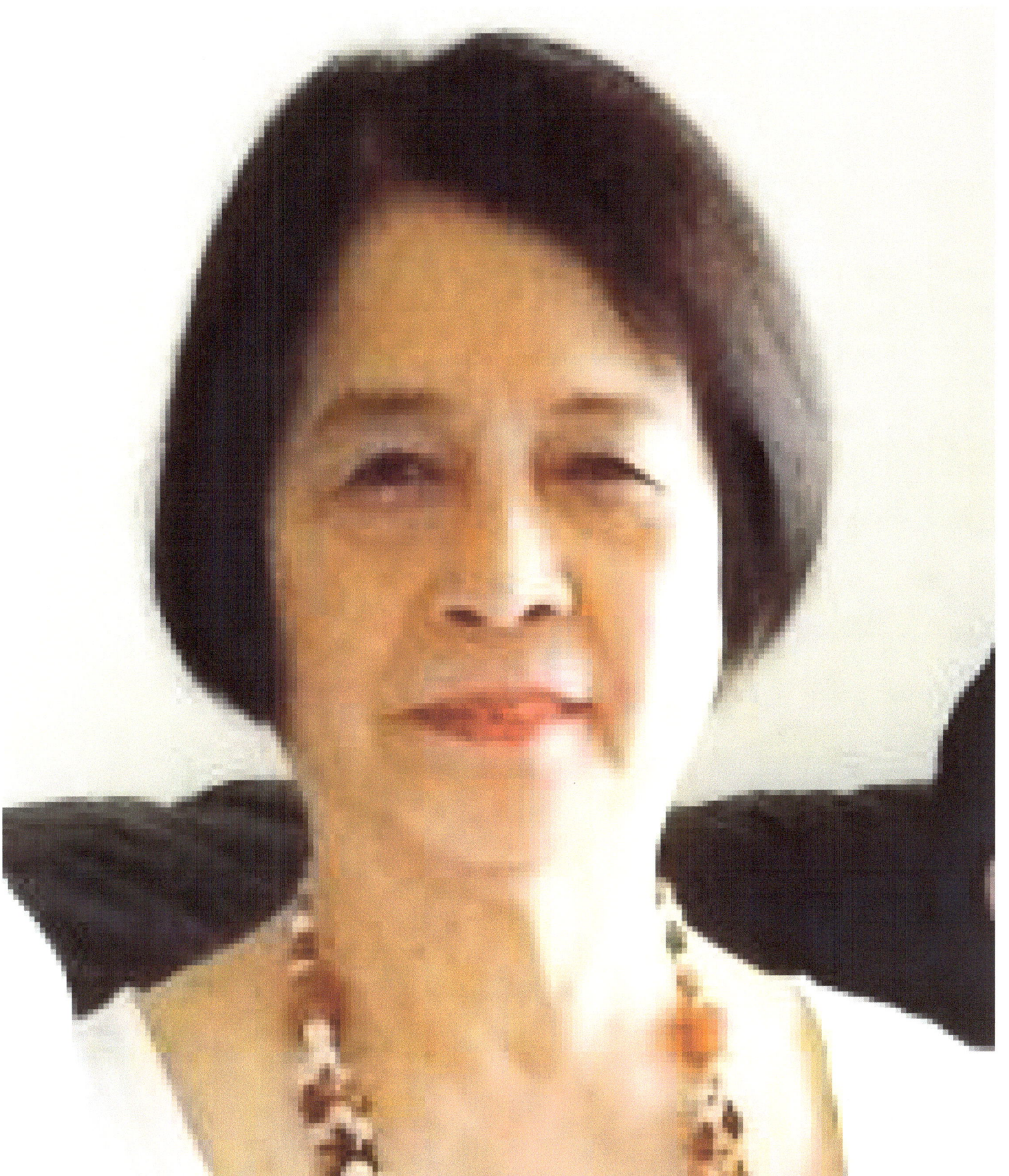

Grace Esmeralda, Abeth's sister

Portraits Album

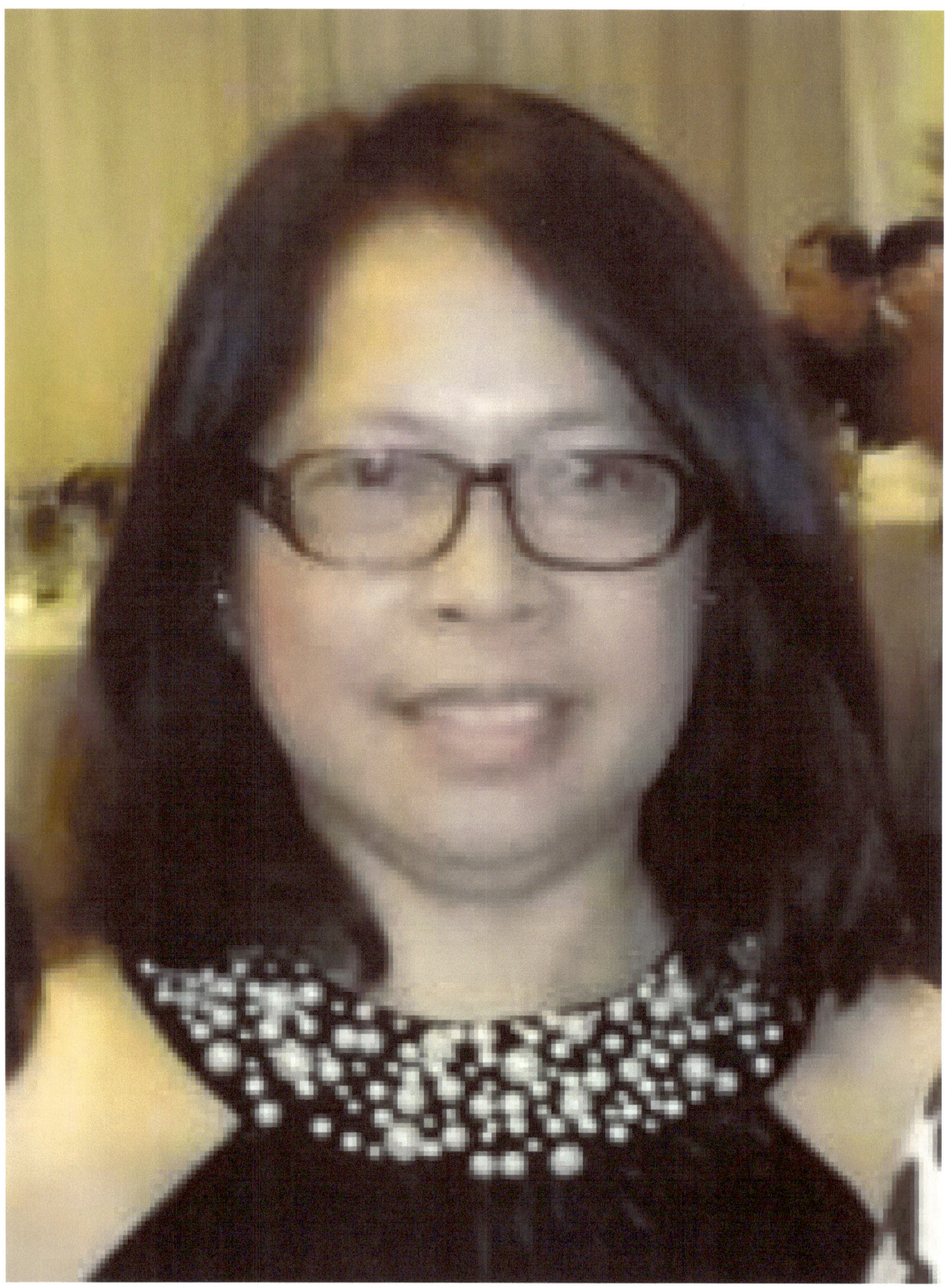

Maydee Esmeralda, Abeth's sister

Portraits Album

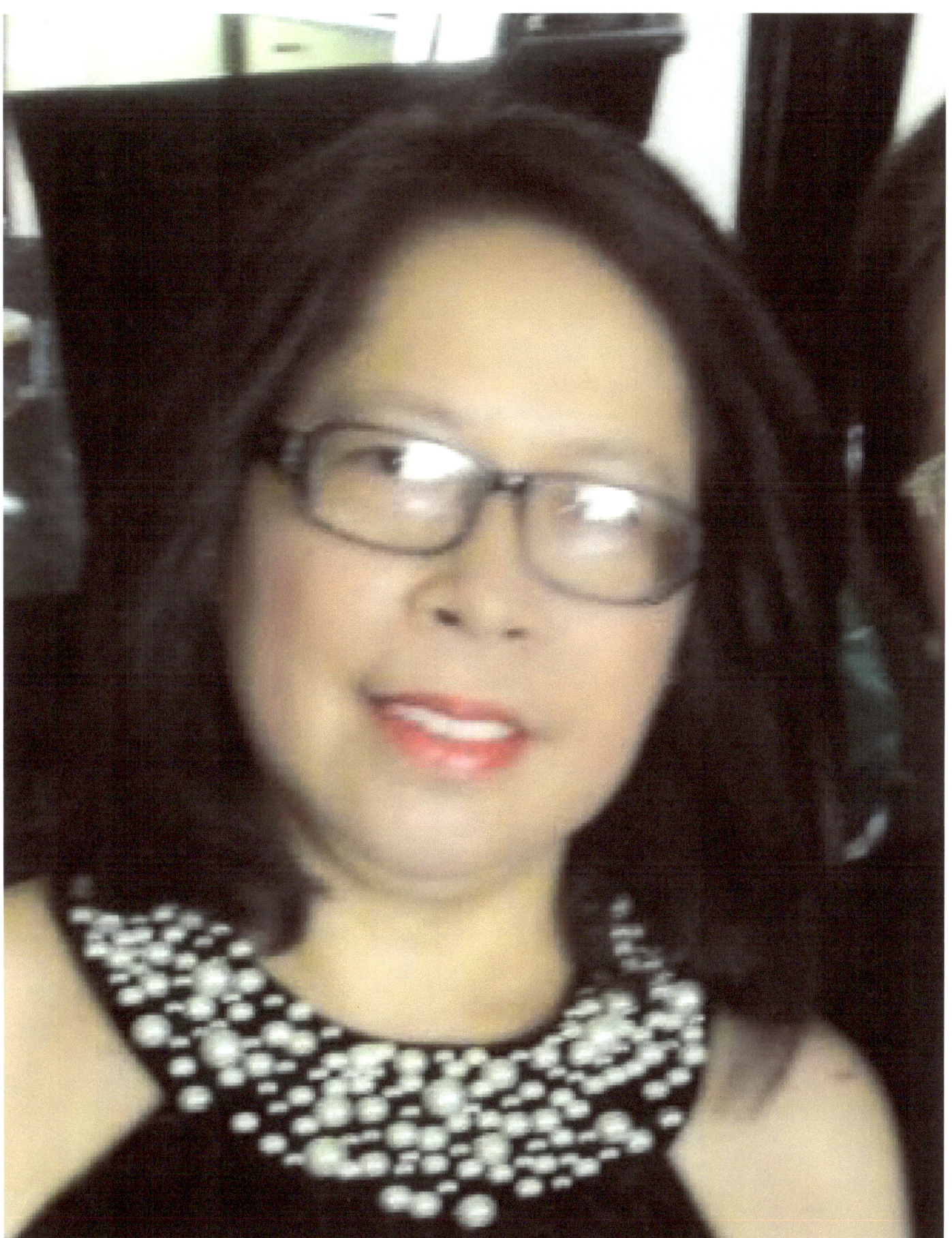

Maydee Esmeralda, Abeth's sister

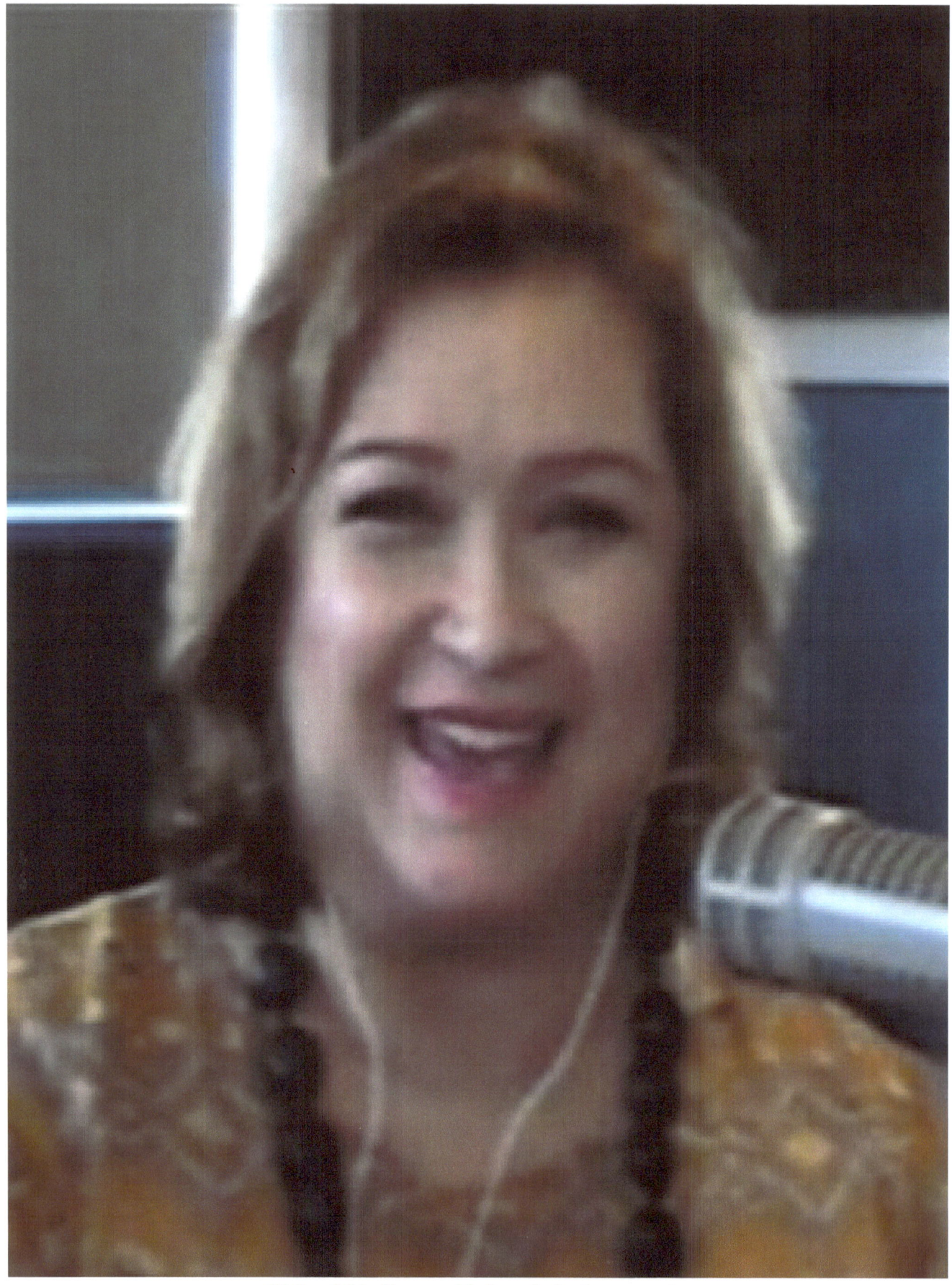

Chiqui Hollman-Yulo, Jobo's cousin

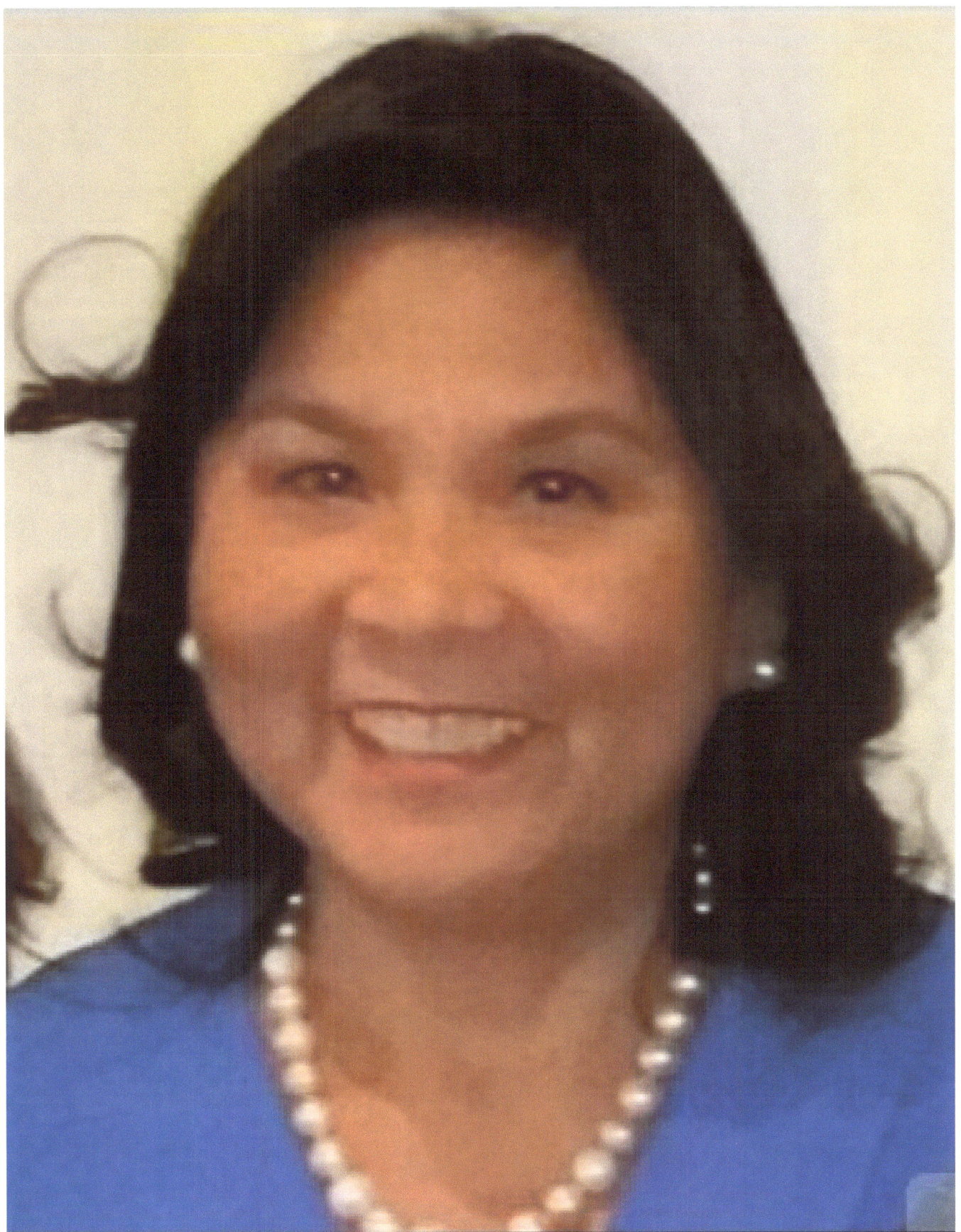

Anita (Annie) Olis Moran, abeth's cousin

Portraits Album

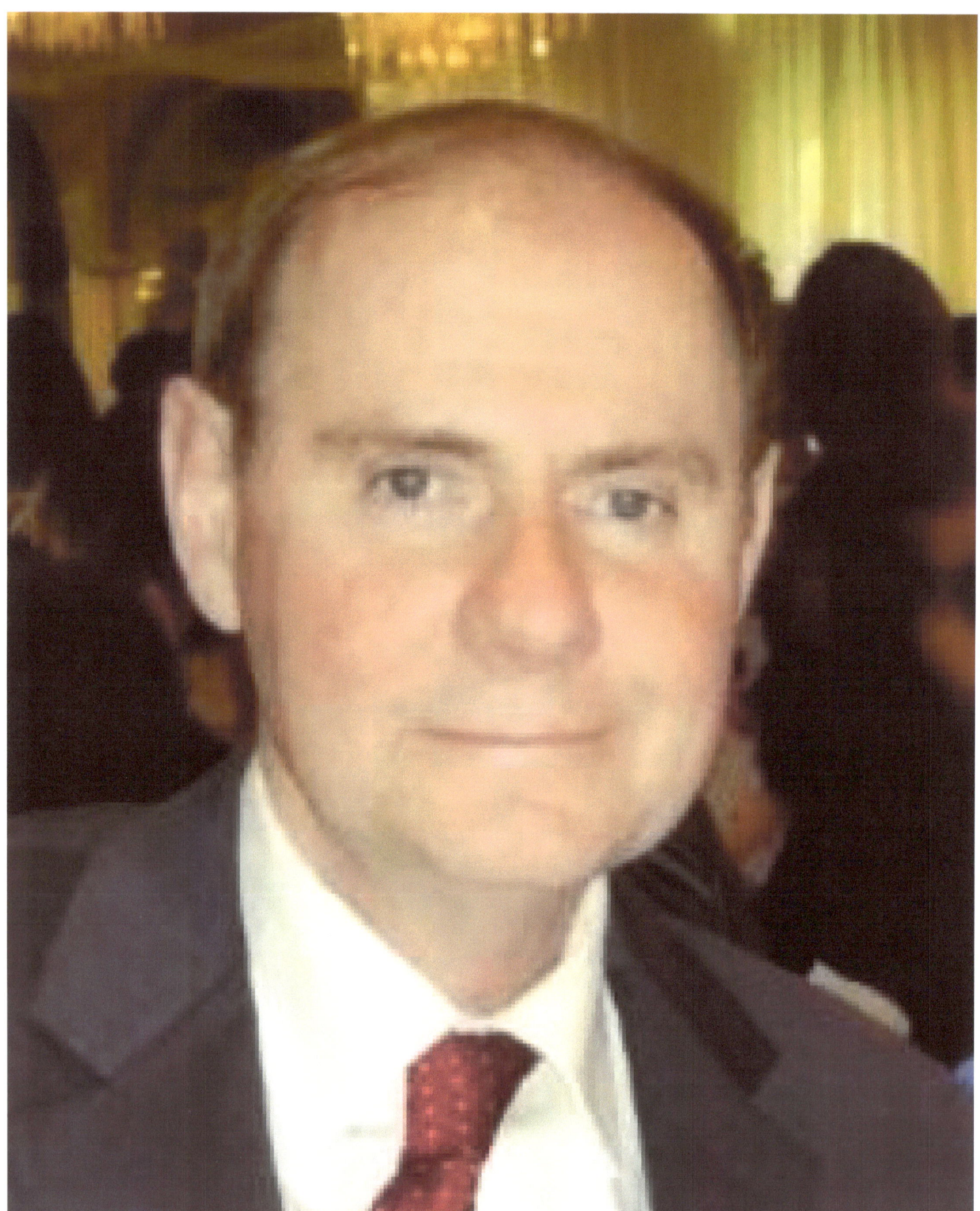

Barry Moran, Anita's husband

Portraits Album

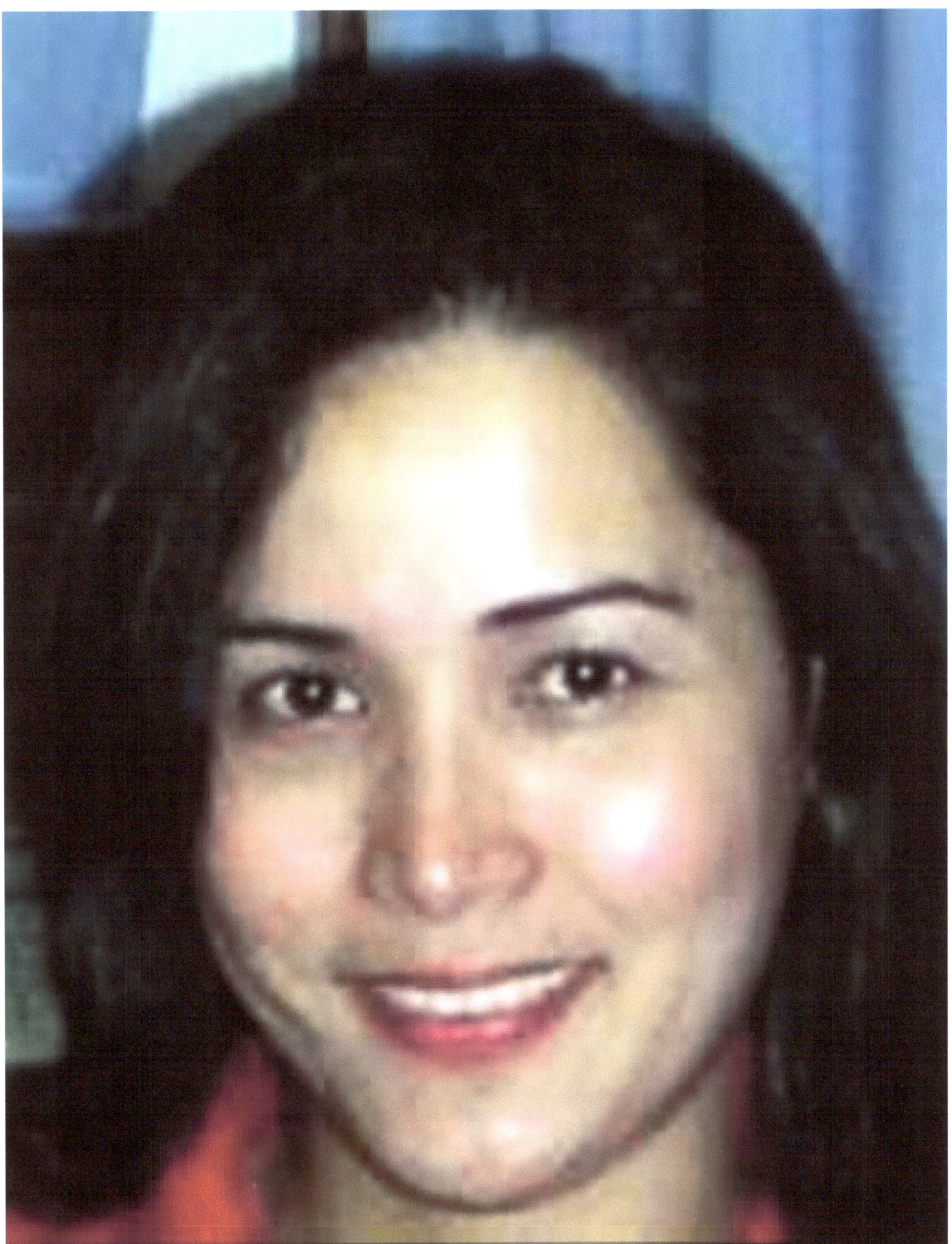

Genalin Esmeralda Soriano, Abeth's niece

www.ingramcontent.com/pod-product-compliance
Lightning Source LLC
Chambersburg PA
CBHW051109180526
45172CB00002B/837